Pr

OVER NEW YORK

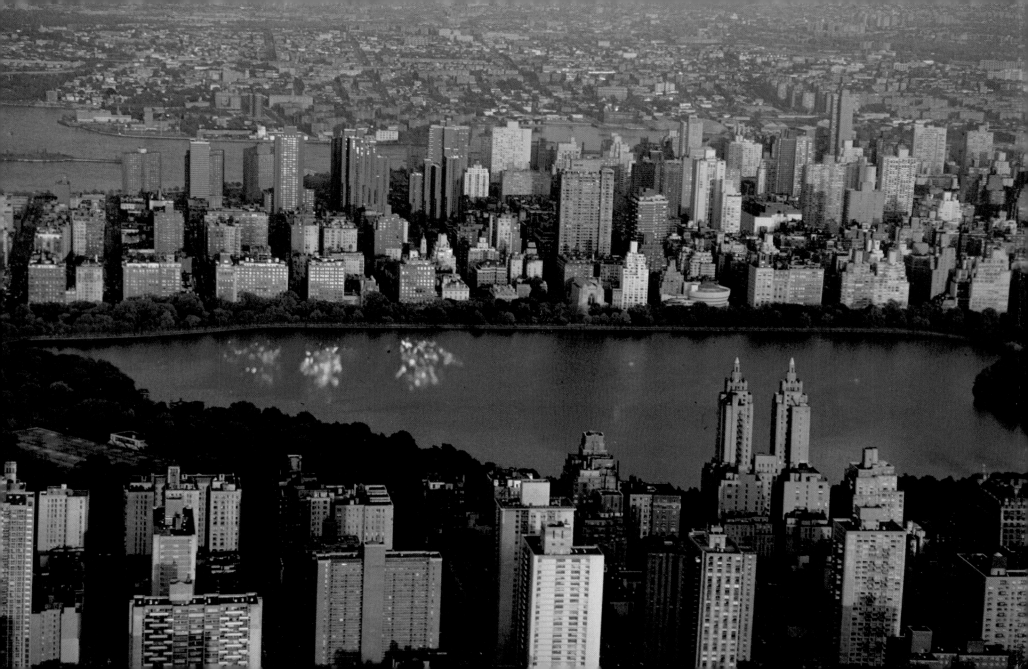

STEPHEN PROEHL

OVER NEW YORK

1980 HOUGHTON MIFFLIN COMPANY BOSTON

Books by Stephen Proehl

OVER CAPE COD AND THE ISLANDS
OVER NEW YORK

Library of Congress Cataloging in Publication Data

Proehl, Stephen.
Over New York.
1. New York (City)—Aerial photographs.
I. Title.
F128.37.P7 917.47′1 79–23660
ISBN 0–395–29096–1
ISBN 0–395–29097–X pbk.

Printed in the United States of America

H 10 9 8 7 6 5 4 3 2 1

FRONTISPIECE: Central Park

Signed, limited-edition prints are
available through the photographer:

Stephen Proehl
Box 414
Groton, Massachusetts 01450

TO MATTHEW AND AIMEE

ACKNOWLEDGMENTS

This book was made possible by pilots Patrick D'Amore, Jack La-Flamme, and Dean MacIsaac, and the facilities at Teterboro Aircraft Service; my editor, Daphne Abeel, and the staff at Houghton Mifflin; photo researcher Bill Madigan; attorney and accountant Bill Truslow and Neal Harte, respectively; bankers Charles Cullen and Patricia Parker; camera store owner Will Garrick; graphic and technical consultants Bill Harris, Steve Jewett, and Nick Wheeler; friends, for enduring hours of slide presentations; my father, Paul Proehl, for his advice throughout the project; Susan, for being my wife and partner.

—STEPHEN PROEHL

CONTENTS

ORDER OF THE PLATES

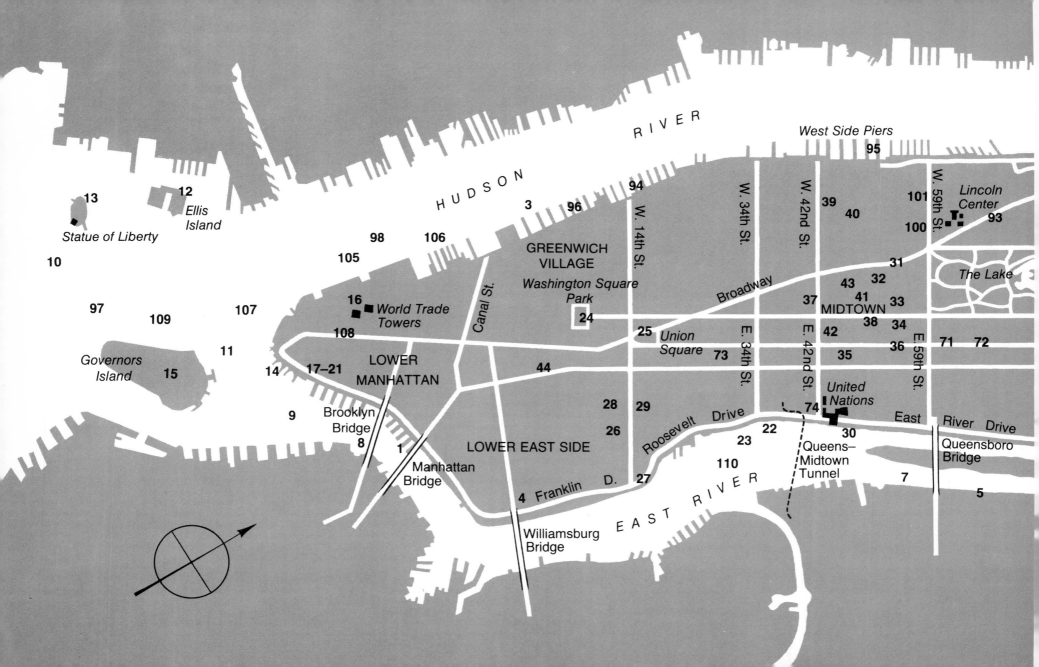

HUDSON RIVER

West Side Piers

95

Ellis Island

13

12

Statue of Liberty

10

97

109

107

11

Governors Island

15

14

17–21

9

Brooklyn Bridge

8

1

Manhattan Bridge

98

106

105

16

World Trade Towers

108

LOWER MANHATTAN

3

96

94

Canal St.

GREENWICH VILLAGE

Washington Square Park

24

25

Union Square

73

44

28

29

26

27

4 Franklin

LOWER EAST SIDE

W. 14th St.

Broadway

E. 34th St.

W. 34th St.

Roosevelt Drive

D.

110

Williamsburg Bridge

W. 42nd St.

39

40

101

W. 59th St.

Lincoln Center

93

100

31

43

32

37

41

MIDTOWN

33

38

34

42

35

36

71

72

E. 42nd St.

United Nations

74

22

23

30

Queens– Midtown Tunnel

East

River Drive

7

Queensboro Bridge

5

The Lake

E. 59th St.

EAST RIVER

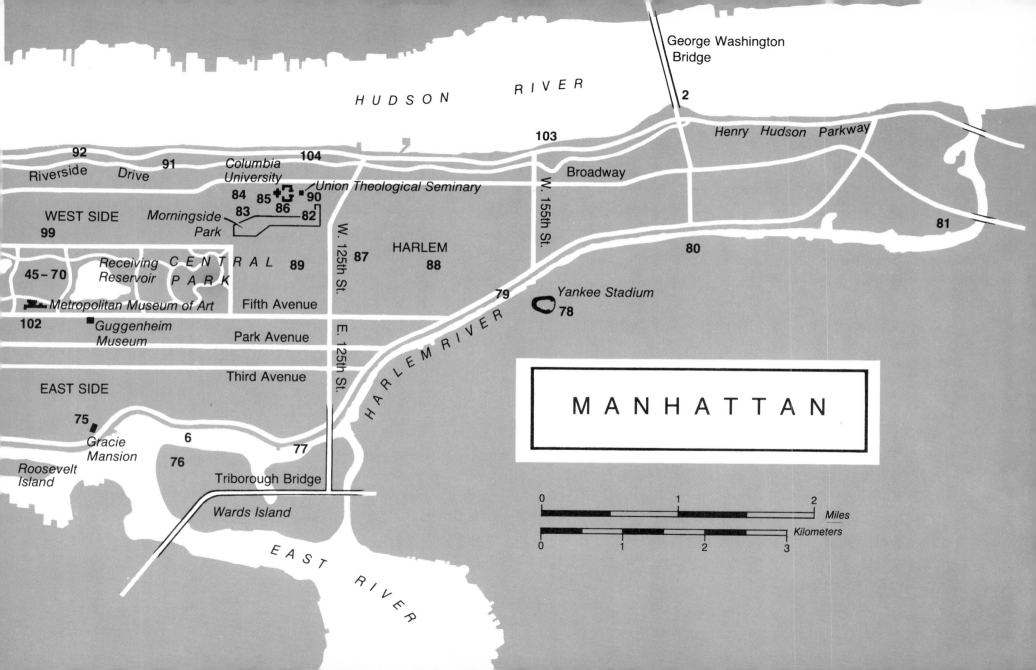

George Washington
Bridge

HUDSON RIVER

2

Henry Hudson Parkway

103

92

91

104

Riverside Drive

Columbia University

Broadway

W. 155th St.

Union Theological Seminary

84
85
86
90

83
82

81

WEST SIDE

Morningside Park

HARLEM

99

80

45 – 70

Receiving Reservoir

C E N T R A L

P A R K

89

87

88

W. 125th St.

Metropolitan Museum of Art

Fifth Avenue

79

78

Yankee Stadium

102

Guggenheim Museum

Park Avenue

HARLEM RIVER

Third Avenue

EAST SIDE

E. 125th St.

75

6

77

MANHATTAN

Gracie Mansion

76

Roosevelt Island

Triborough Bridge

Wards Island

0 1 2 Miles

0 1 2 3 Kilometers

EAST RIVER

PREFACE

I am not a New Yorker. Friends ask me why I don't move to the City. "If you take your photography seriously," they say, "you should be in New York." I agree. Fortunately, most of us don't take ourselves seriously, or we'd all be in New York.

If I know I am going to New York the excitement surges through me as I begin to organize myself for the big trip to the Electric Island. One of the first things I do is change the message on my answering machine to notify everybody that (1) I am in The Big Apple for big business, and (2) that I will return in three days. (A "week in New York" sounds like pleasure; "three days" smacks of blitzkrieg efficiency.) For sheer intimidation this ranks second only to the traveling New Yorker who hastily, but tactfully, inserts, "I've got to get back to New York."

For most of us, that New York jolt hits when we walk through the automatic doors after claiming our baggage at La Guardia, Kennedy, or Newark airports and find ourselves immersed in a sea of yellow taxis. Even before we're on the island, we move our internal wristwatch to New York Standard Time; the pace slows only when we're back on the plane and the FASTEN YOUR SEAT BELT sign goes off.

If you've had the good fortune to catch a glimpse of this magnificent metropolis from a commercial airliner or a private aircraft, you know what a rare treat the aerial experience can be. What on the ground was a flurry of cars, people, and looming buildings becomes instead a slow-motion scene of tranquillity and harmony. Every form and object moves or remains in place with grace, dignity, and beauty. High-rise offices looking like giant cement sequoias scrape the sky, casting their shade across the breadth of the island. Their growth, sustained by a mechanical root system, appears as a natural phenomenon at this altitude. Surrounded by blue fields of water and with stipples of pink cherry blossoms punctuating the citywide green spaces, Manhattan is, on any spring day, a visual gem.

Hovering over New York City in a helicopter can be like watching a party on a summer evening from across the lake or viewing a movie with no sound. The experience is nonparticipatory, uninvolving, remote — it is an alien picture of life on earth. We cannot, from this perspective, touch, smell, hear, or taste what this city has to offer.

Over the city, one has a prevailing sensation of omniscience and bliss. The drone of the air-slapping blades that keep this iron bird

aloft would never allow the scream of a firetruck's siren to pierce the ear, but we can follow the vehicle snaking through the cracks and crevices of that concrete maze and the first thought that comes is — what is all the fuss about? Similarly, we can't feel the flexing thighs and lung-heaving gasps of a soccer game, but we recognize a higher purpose as the design plays out beneath us: each player in his place, four neatly etched lines defining the boundaries of the performance, as a round white object moves randomly from end to end.

Another pocket of activity engages the eye as a tugboat guides four unwieldy garbage barges across the Upper Bay. The sight of the refuse conjures up an aroma that provides an imaginary break from the odor of spent aviation fuel that eddies throughout the cockpit. Farther to the north, Riverside Drive is snarled with rush-hour commuters. The cars look like a permanent part of the landscape, and the frustration of the passengers within doesn't concern me.

Before we drift too far in this daydream and find the wax on our legendary wings melting, we are struck by the elements of order, discipline, and simplicity that are so all-pervasive. How could so many people with so many different backgrounds and goals build a city that even at its most troublesome times provides water, food, fuel, shelter, and culture to its own inhabitants and millions of visitors. Down there the answer is incomprehensible; up here we can understand. The Tinker-Toy bridges carry the workers and provisions. These links serve as mooring lines that keep Manhattan from floating adrift. Flowing away from the bridges come streets and avenues carrying the townspeople to the elevated workshops. Laid out in gridlike fashion these arteries circulate east to west, north to south, the monotony broken here and there by a few diagonal slashes and, in the center, a large rectangular park.

Navigating at night by the Connecticut coast, we are on our way back now. The blaze over Midtown beckons us to return to the party we didn't want to leave. With the serene glow of another city on the horizon, I lean toward the pilot and tell him, "I've got to get back to New York."

STEPHEN PROEHL

Groton, Massachusetts

xv

LOWER MANHATTAN
THE UPPER BAY
EAST RIVER

1 Manhattan and Brooklyn bridges

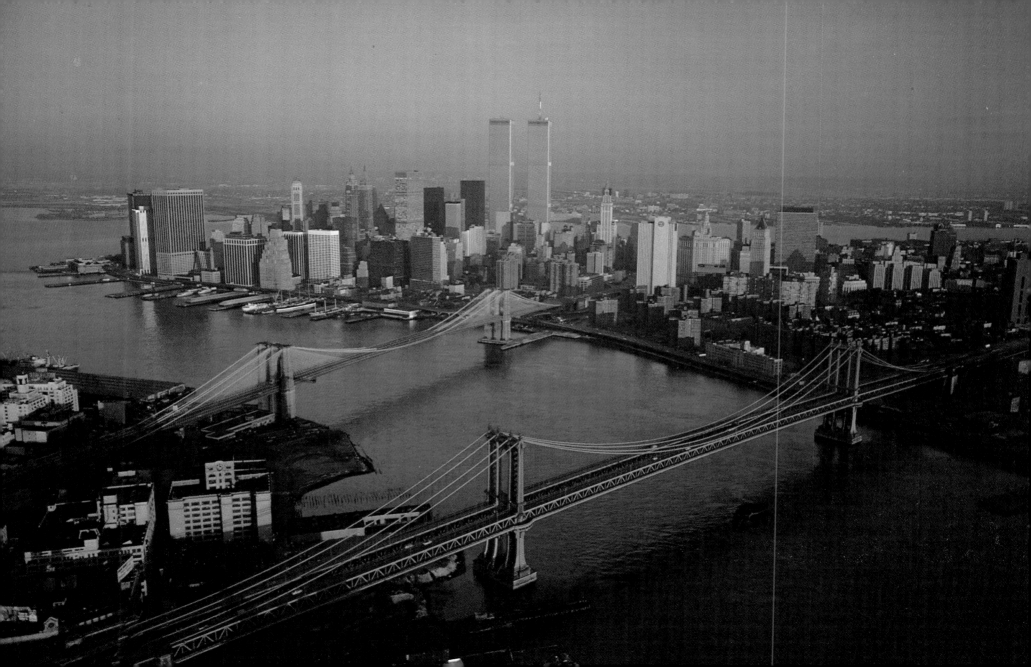

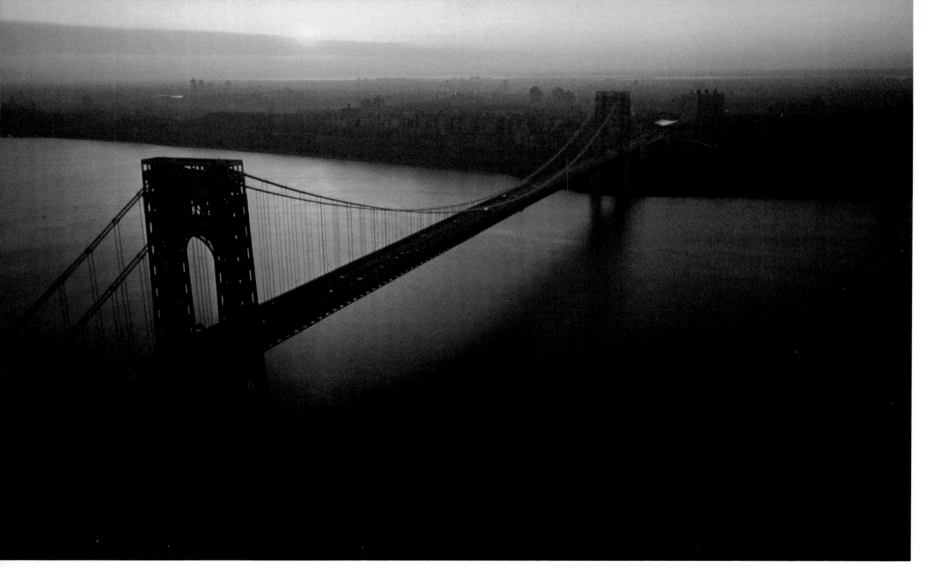

2 George Washington Bridge

3 Sunrise over Manhattan

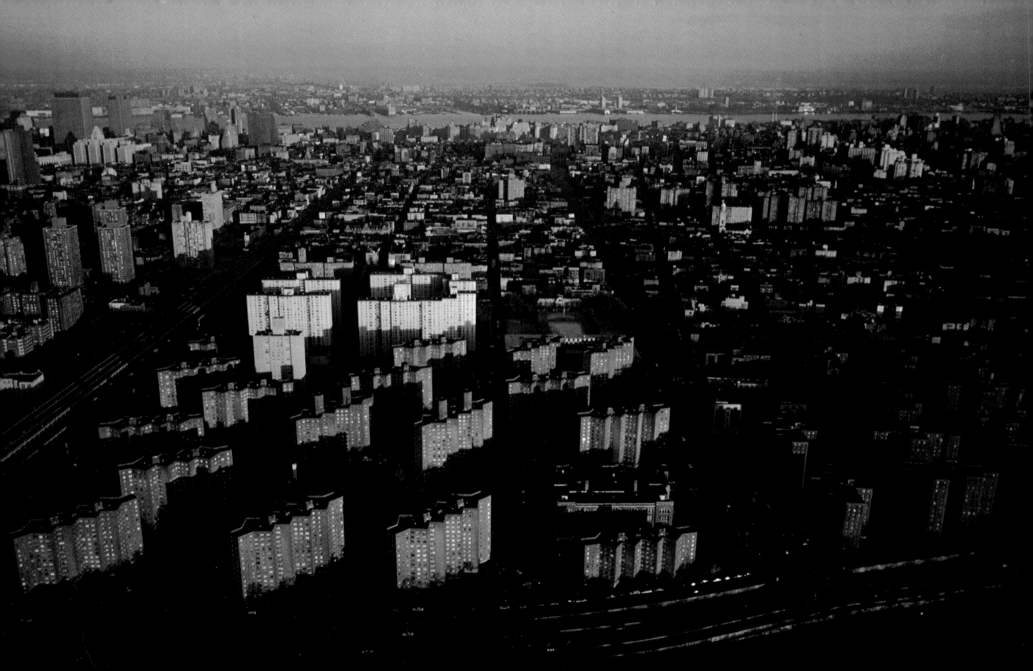

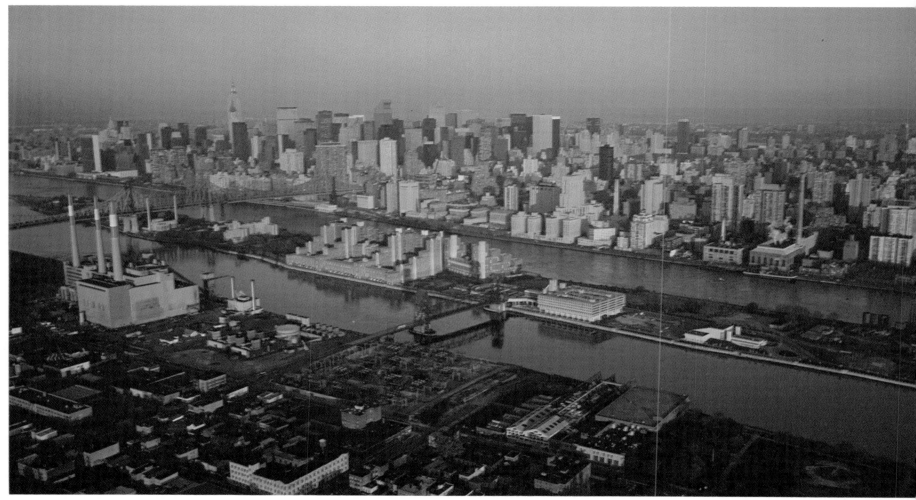

◁ 4 Baruch Houses/East River Drive
 5 Roosevelt Island

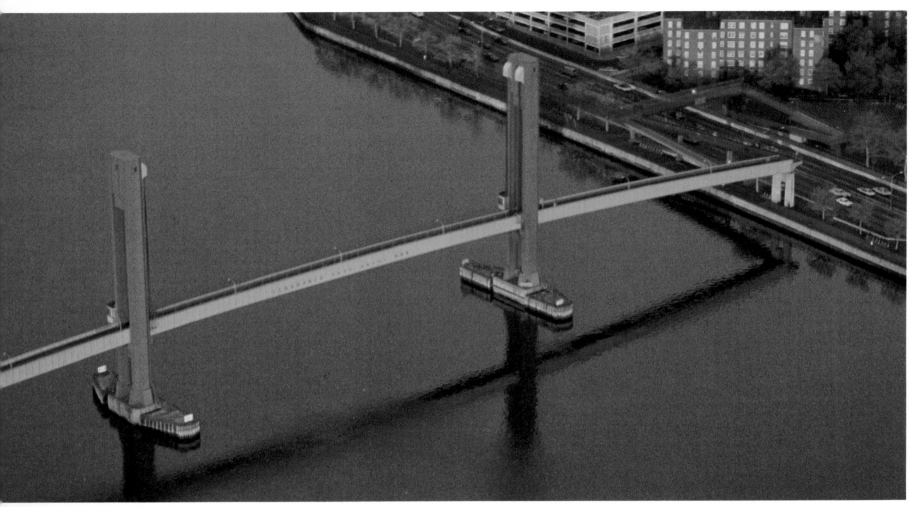

6 Footbridge/East River from Wards Island
7 Queensboro Bridge/East River at Fifty-ninth Street ▷

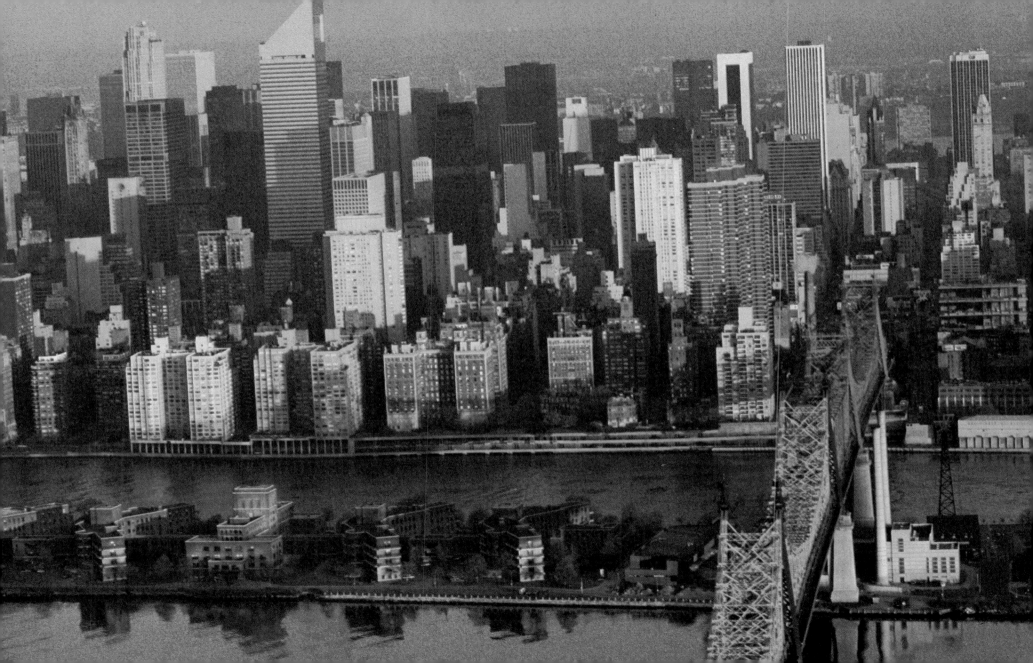

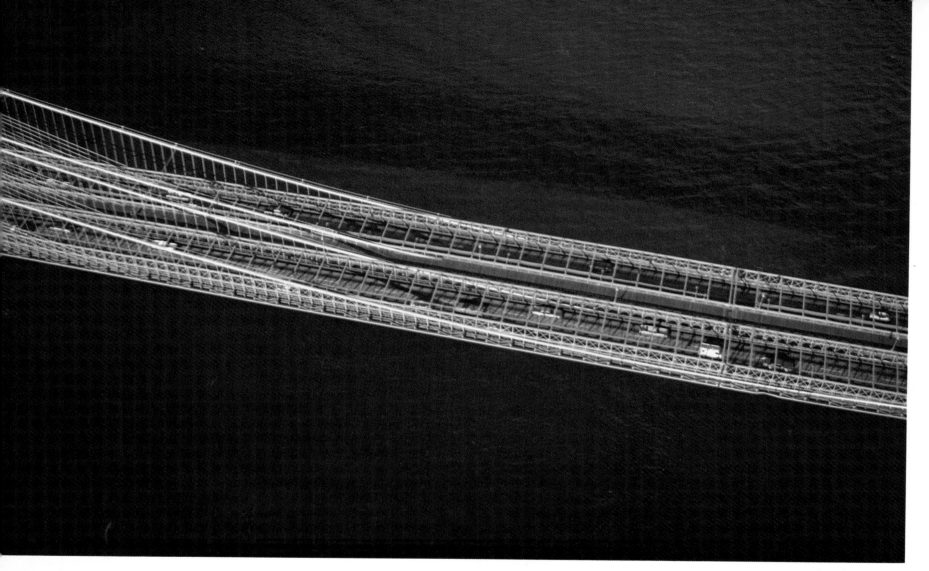

8 Brooklyn Bridge
9 Seaplane/Lower Manhattan ▷

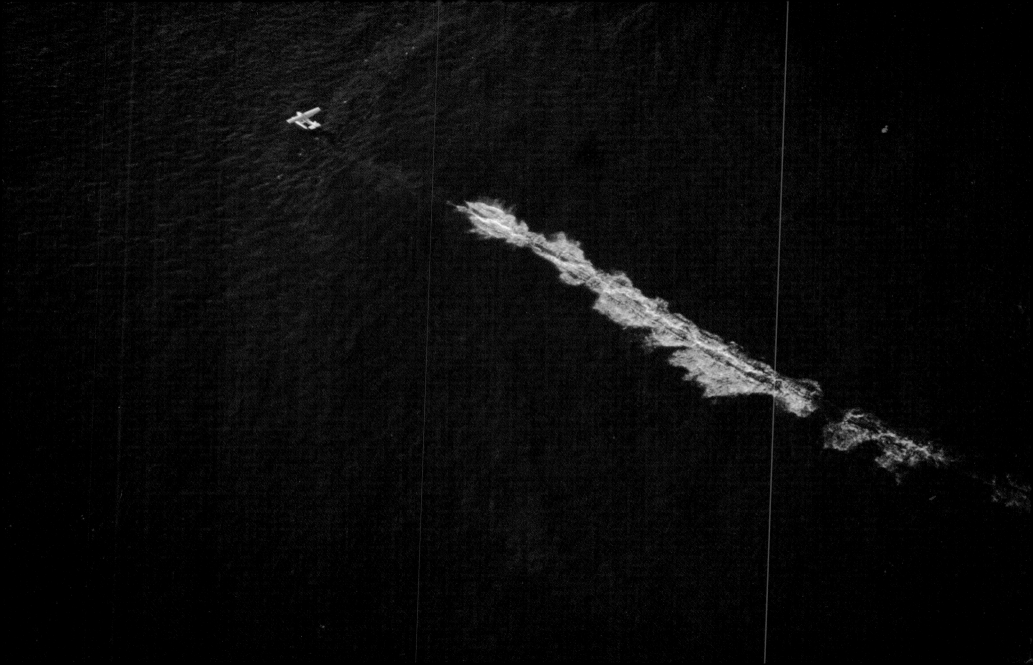

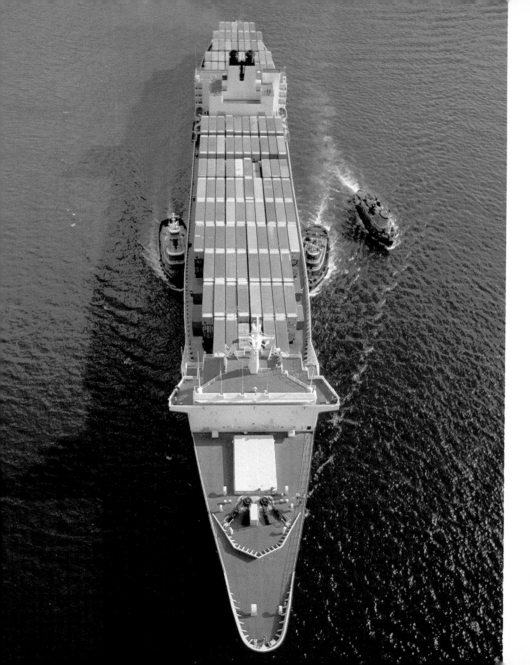

10 Freighter/Upper Bay

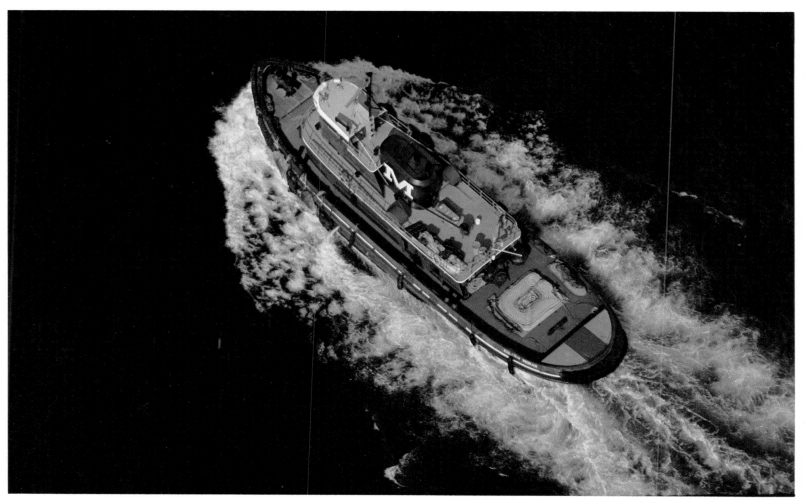

11 Tugboat/Upper Bay

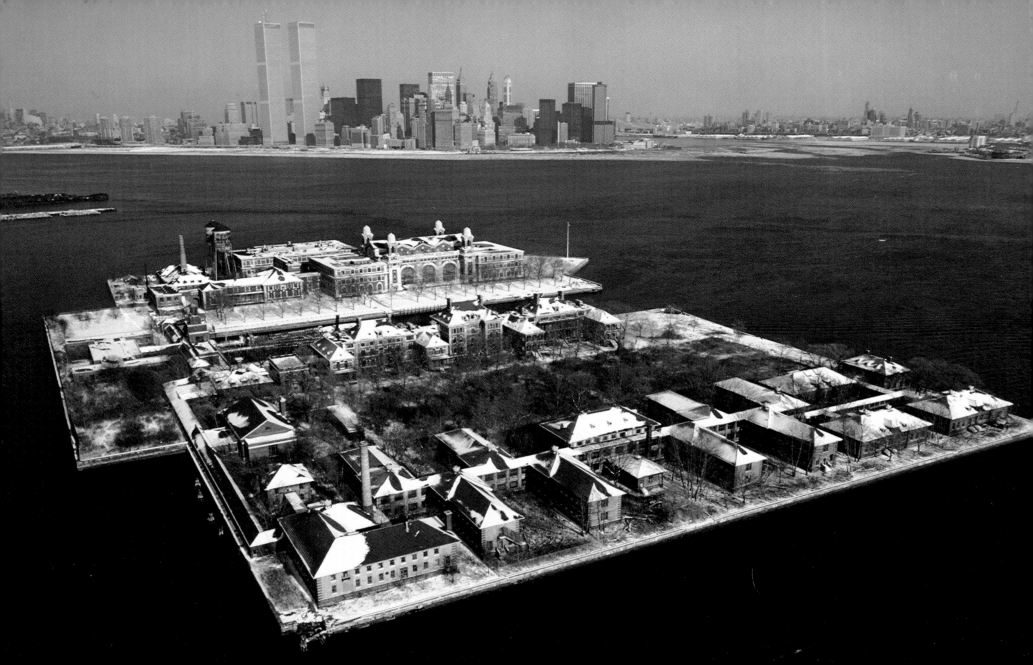

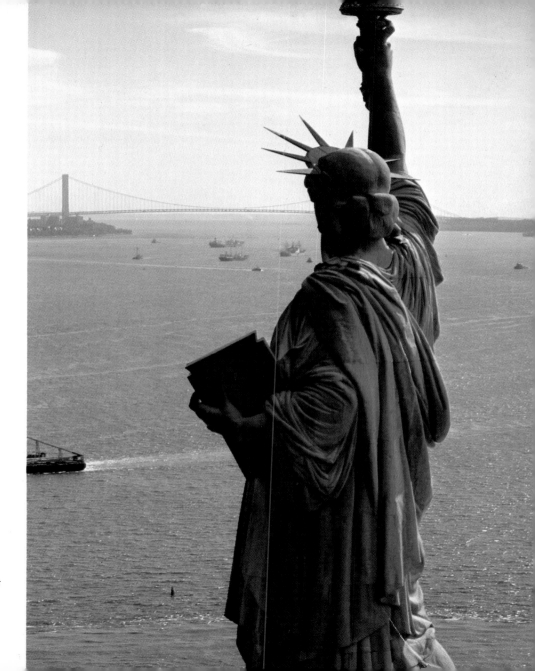

12 Ellis Island 13 Statue of Liberty

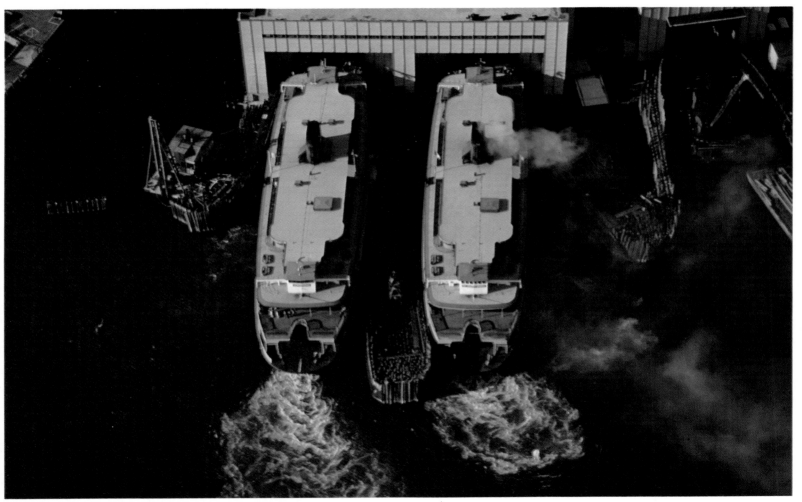

14 Ferry Terminal/Lower Manhattan
15 Governors Island ▷

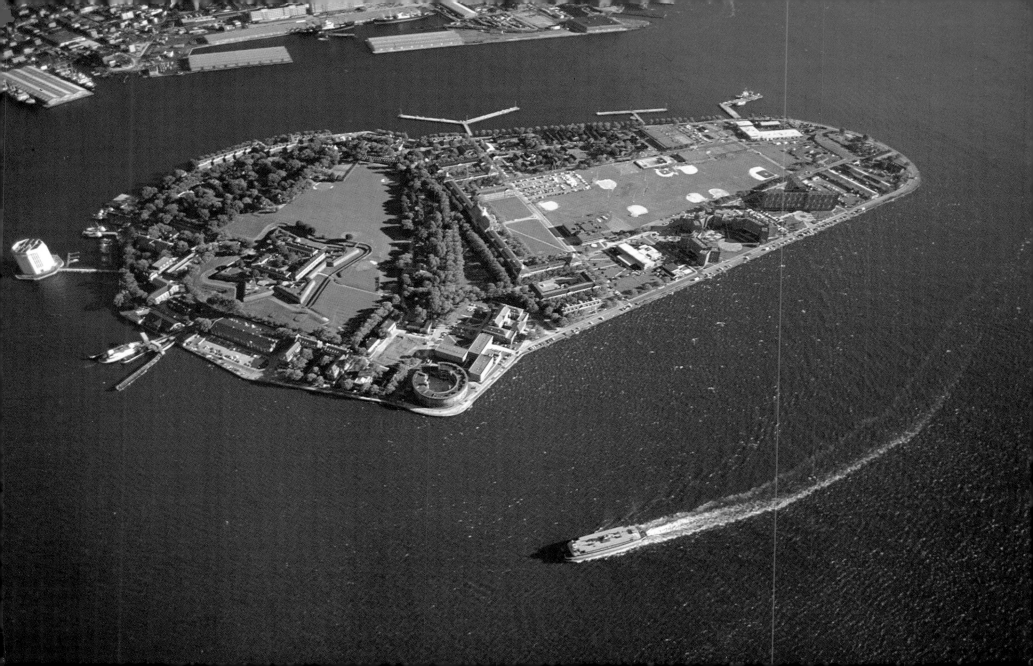

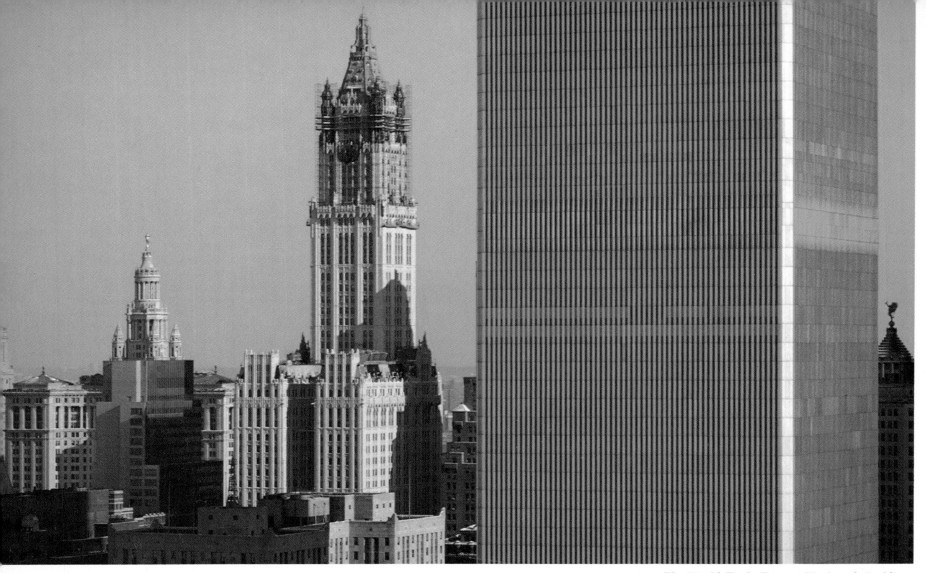

16 The World Trade Towers/Woolworth Building
17 The financial district ▷

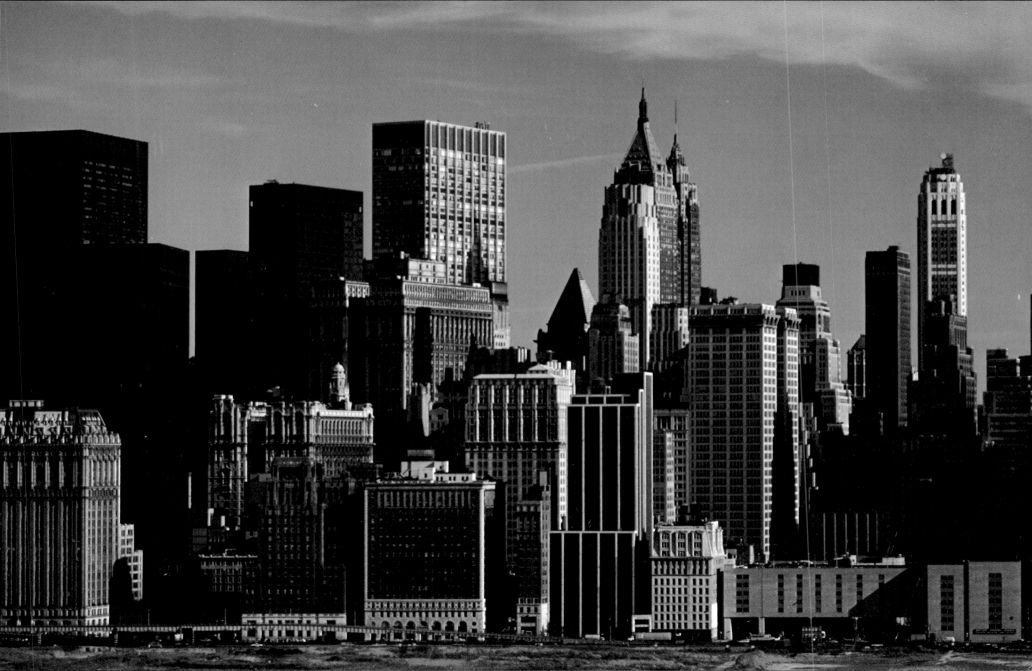

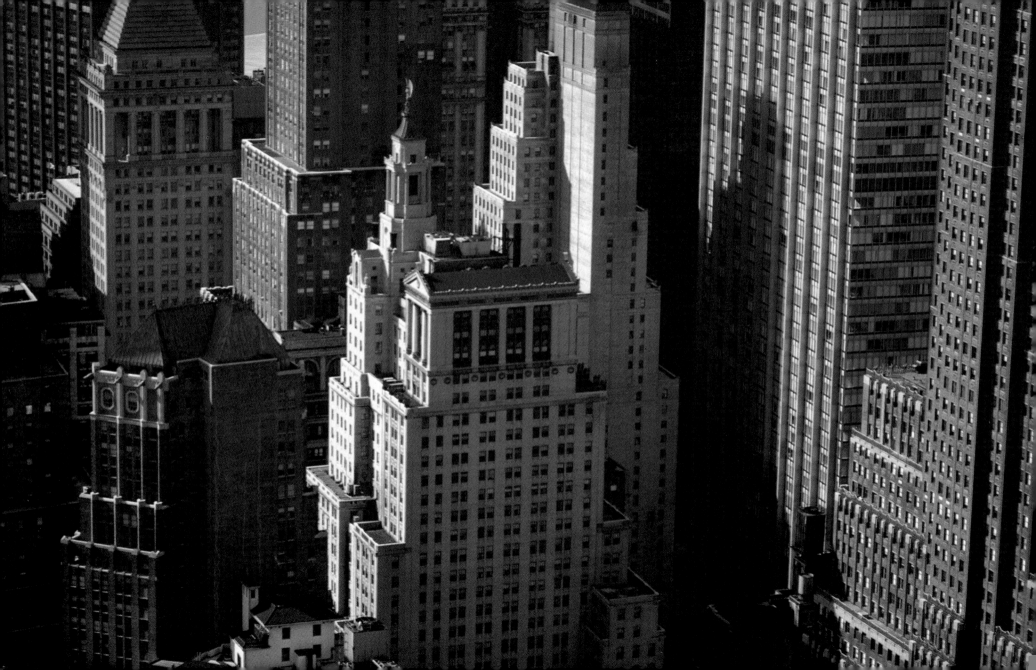

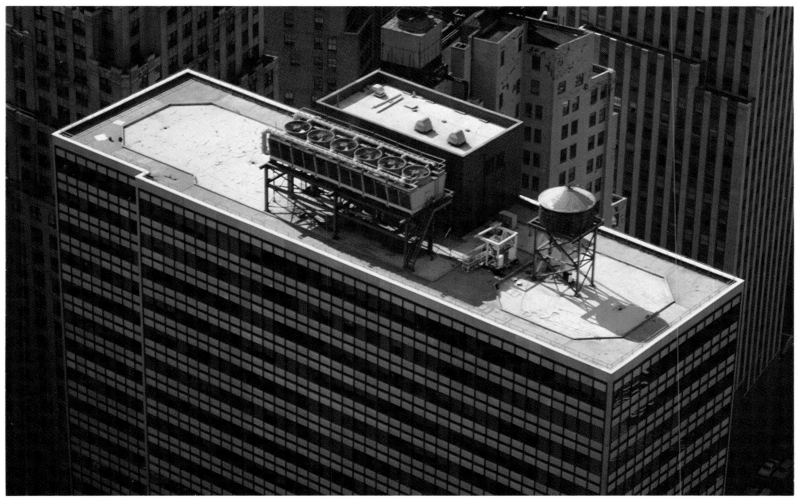

◁ 18 The financial district/Wall Street
19 Water tower/the financial district

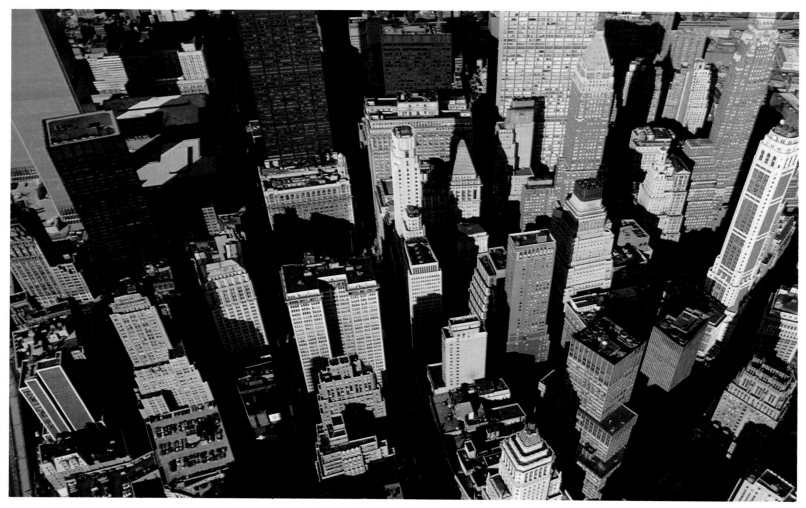

20 The financial district
21 South Street Piers/Seaport Museum ▷

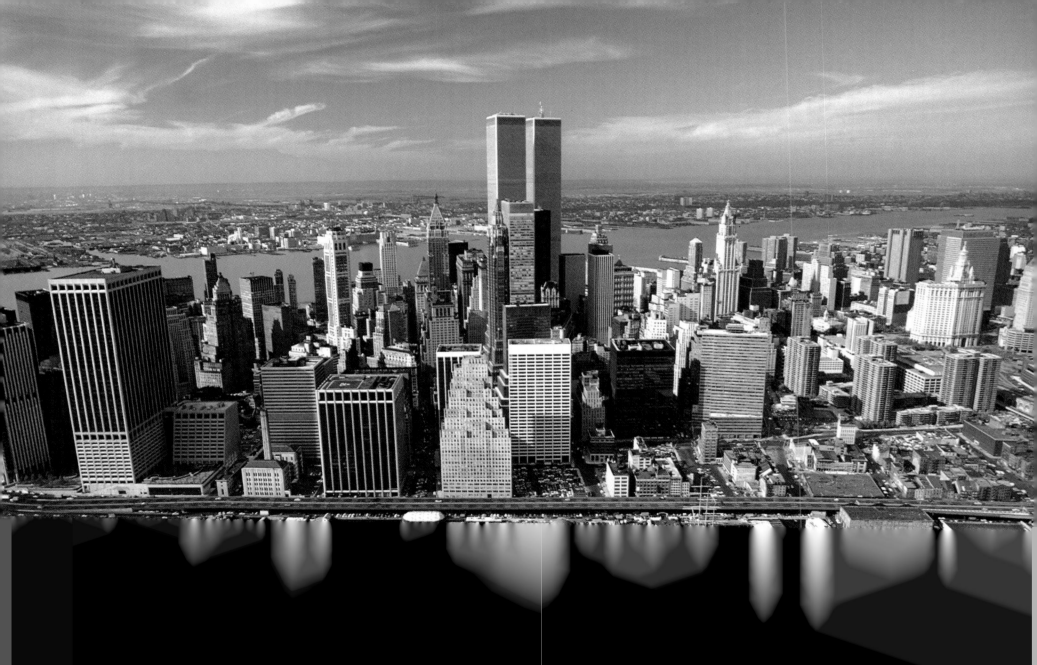

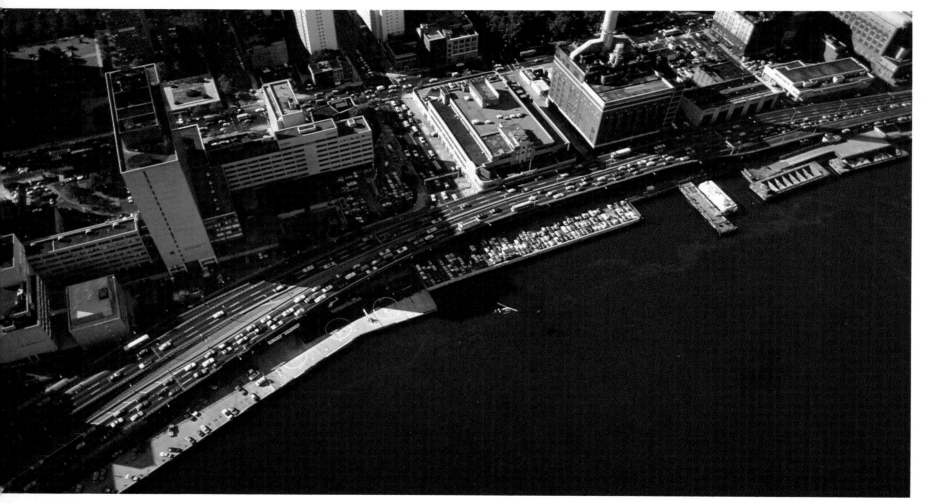

22 Skyport/East Thirty-fourth Street
23 Tugboat/East River ▷

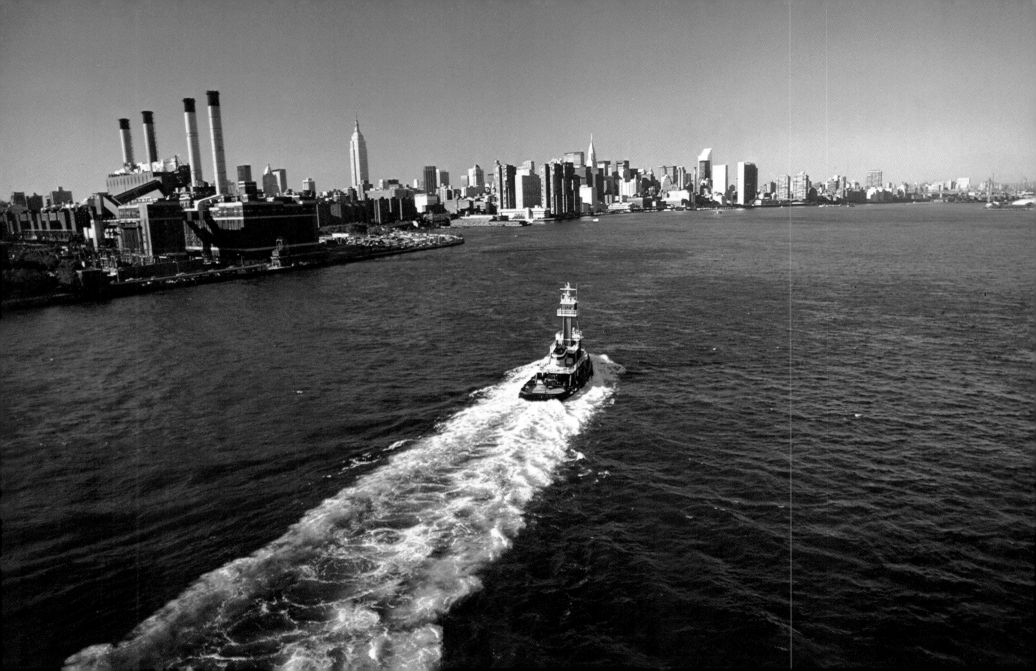

PART II

THE VILLAGES

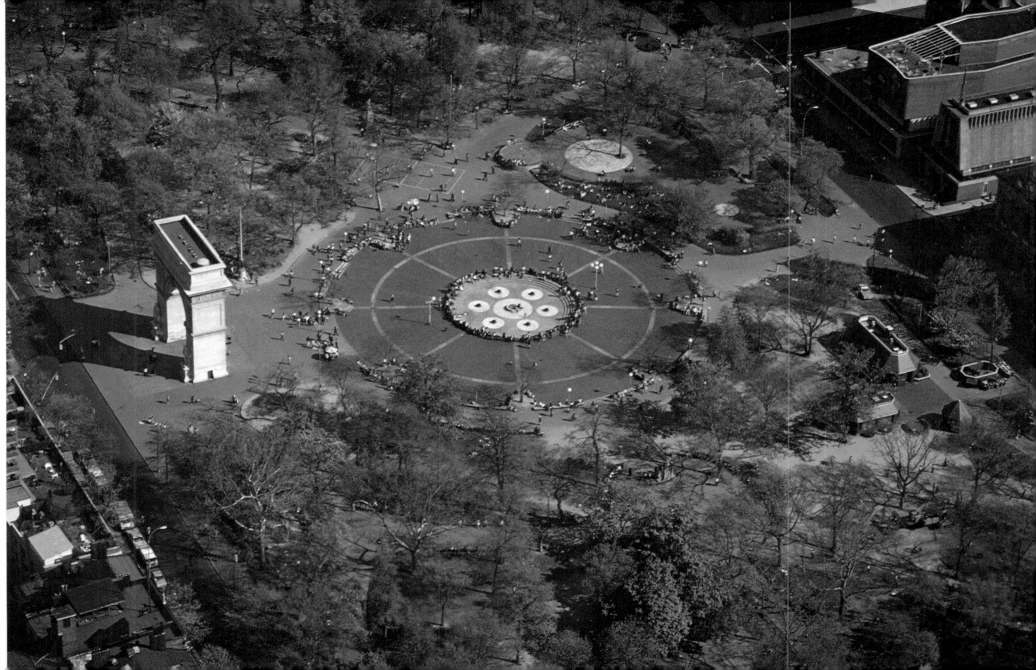

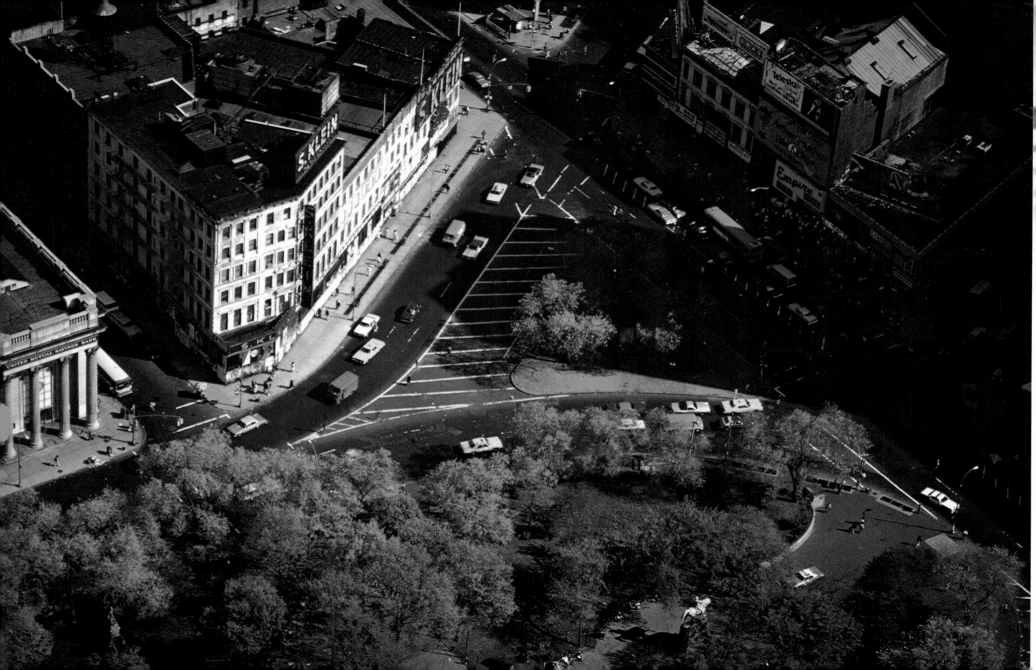

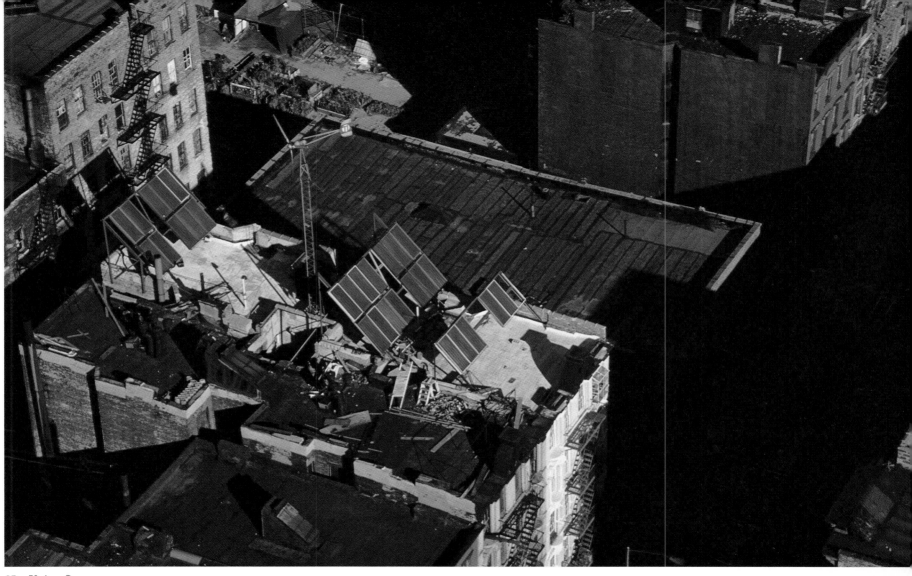

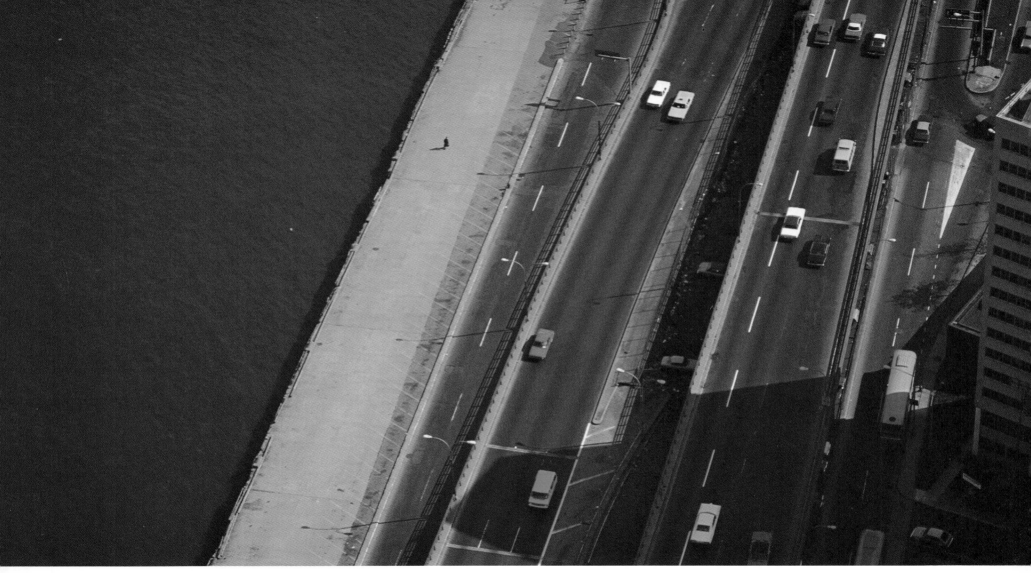

27 Franklin D. Roosevelt Drive

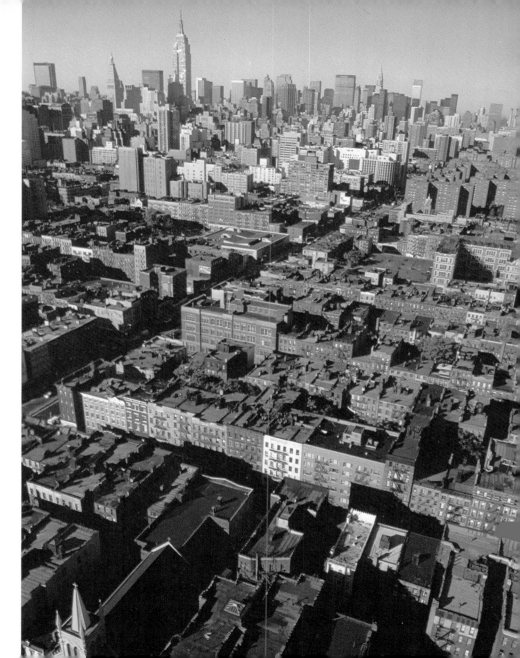

28 The Villages to Midtown

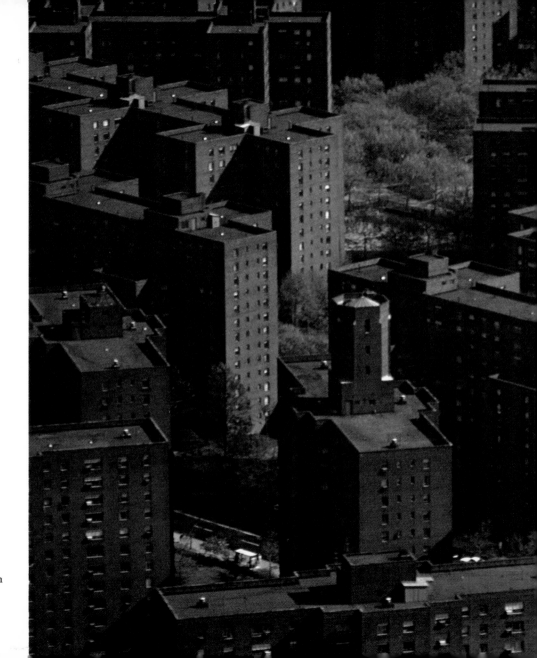

29　Stuyvesant Town

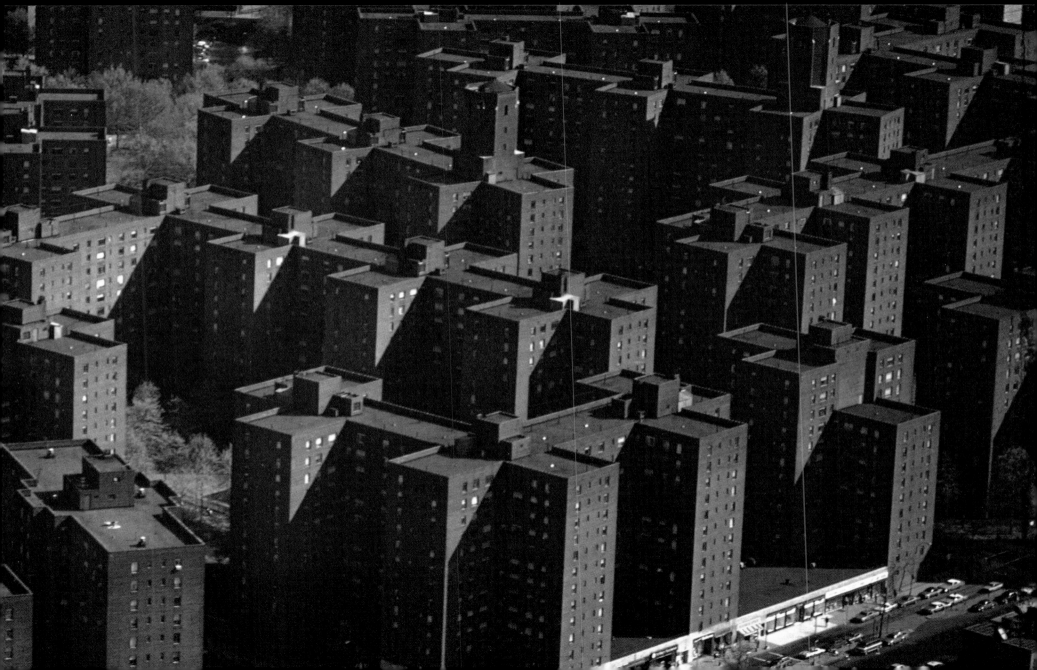

PART III

MIDTOWN

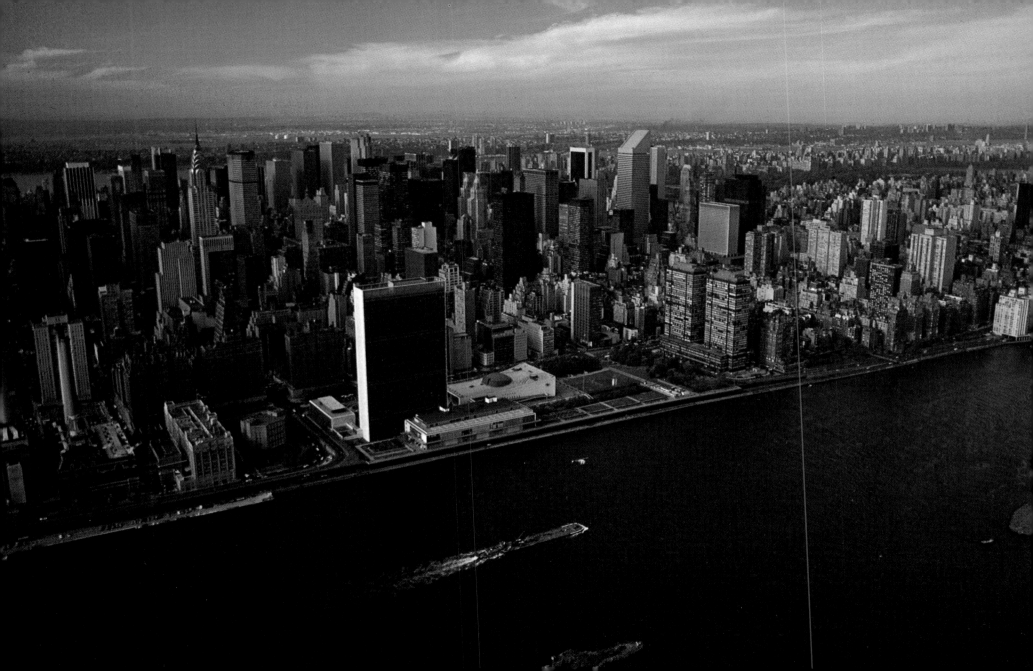

31 Exxon and McGraw-Hill Buildings

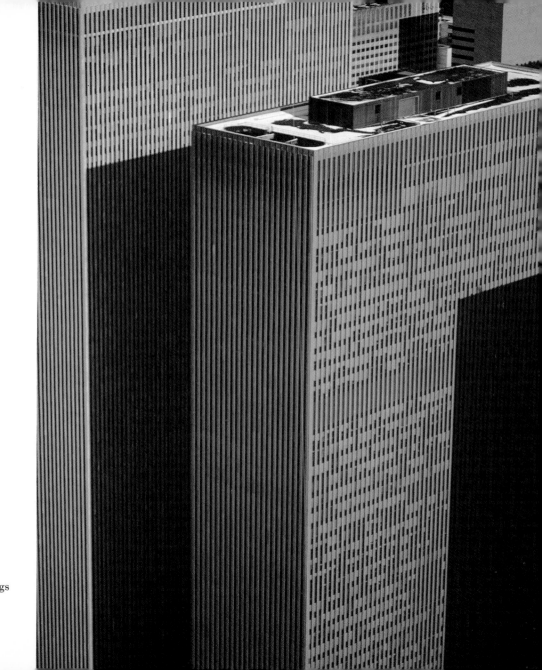

32 Exxon and McGraw-Hill Buildings

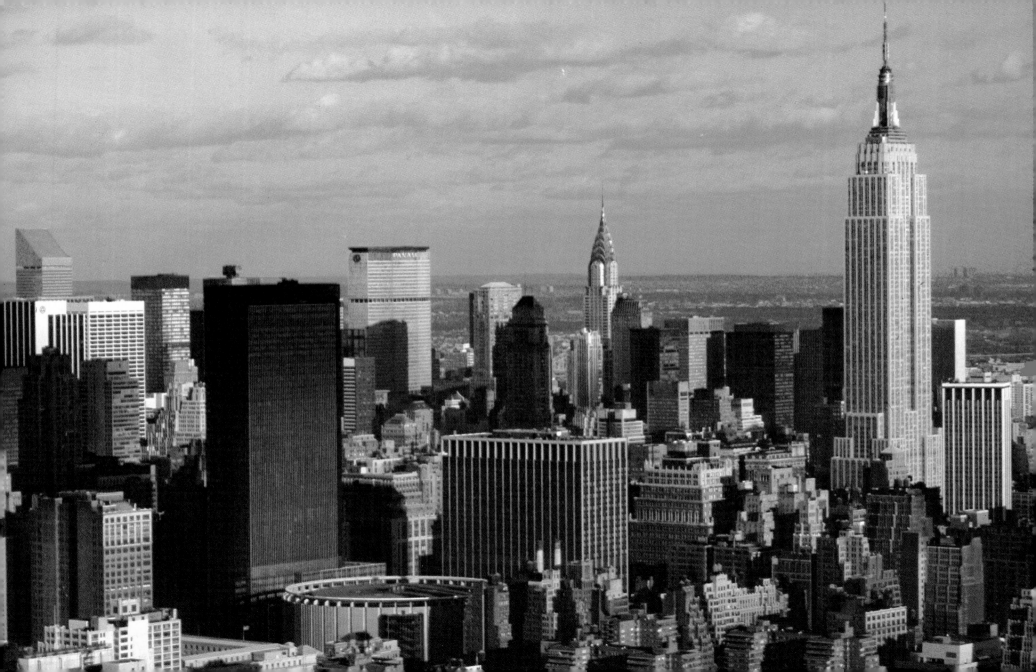

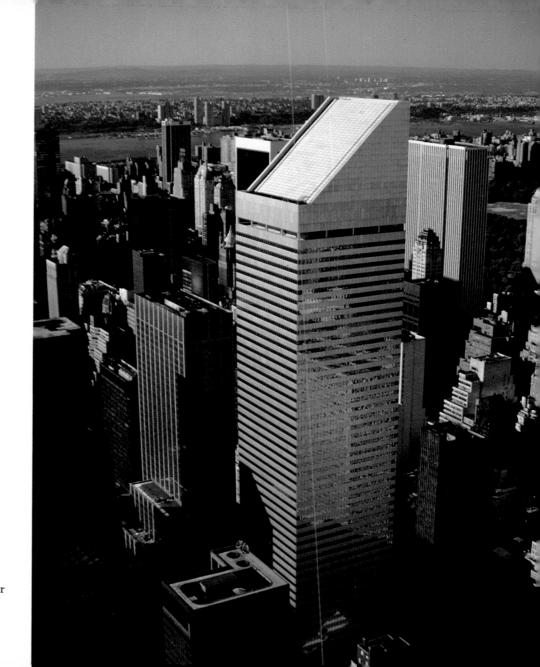

33 Midtown

34 Citicorp Center

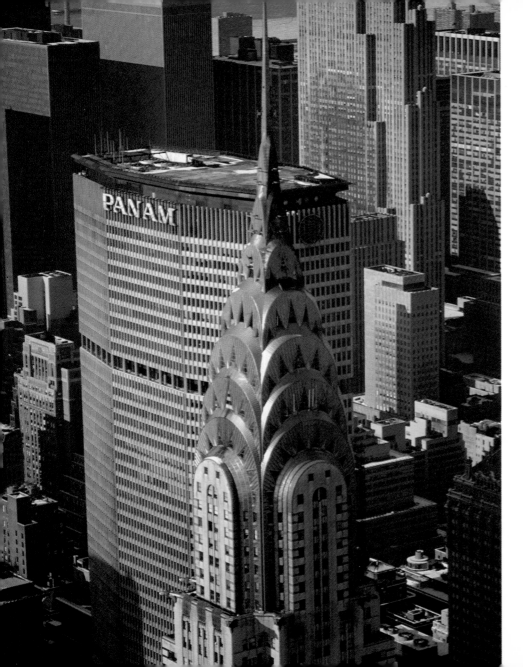

35 Chrysler and Pan Am Buildings

36 Park Avenue and Fifty-third Street

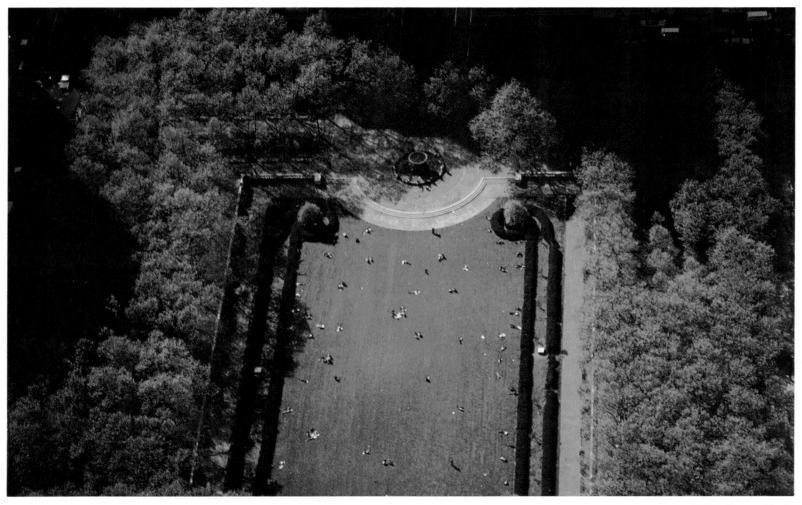

37 Bryant Park
38 St. Patrick's Cathedral/Fifth Avenue ▷

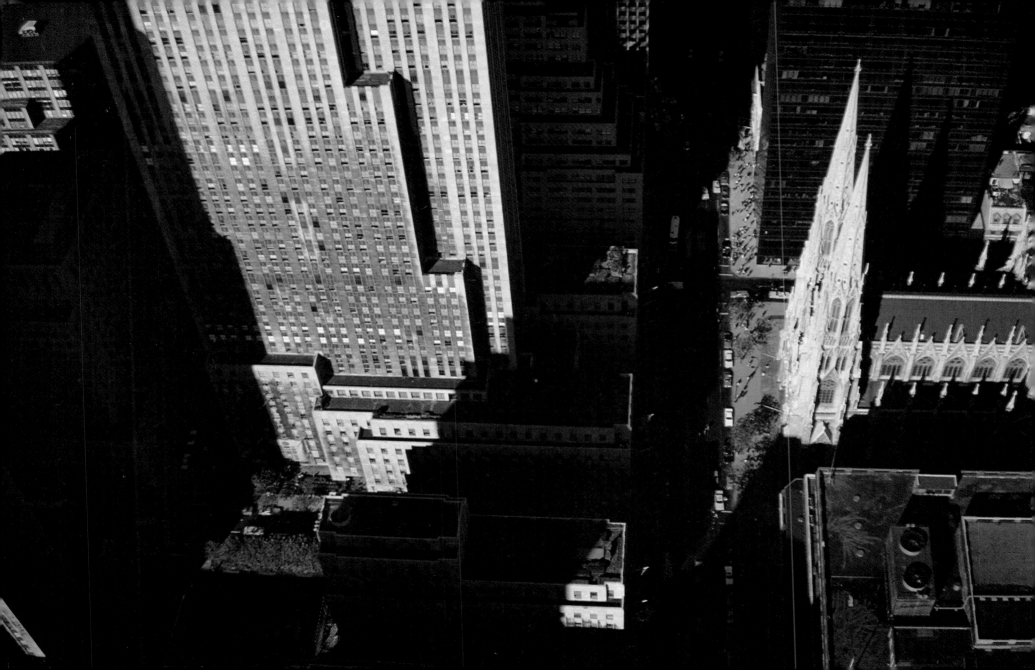

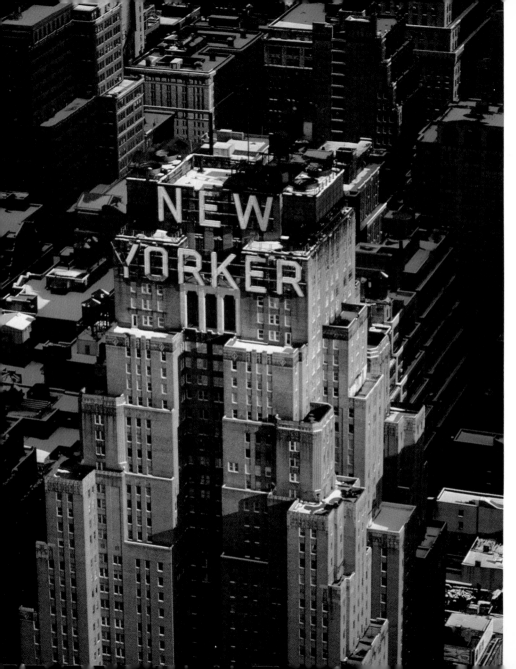

39 The New Yorker

40 Terraced Neo-Gothic Midtown Building

41 Midtown

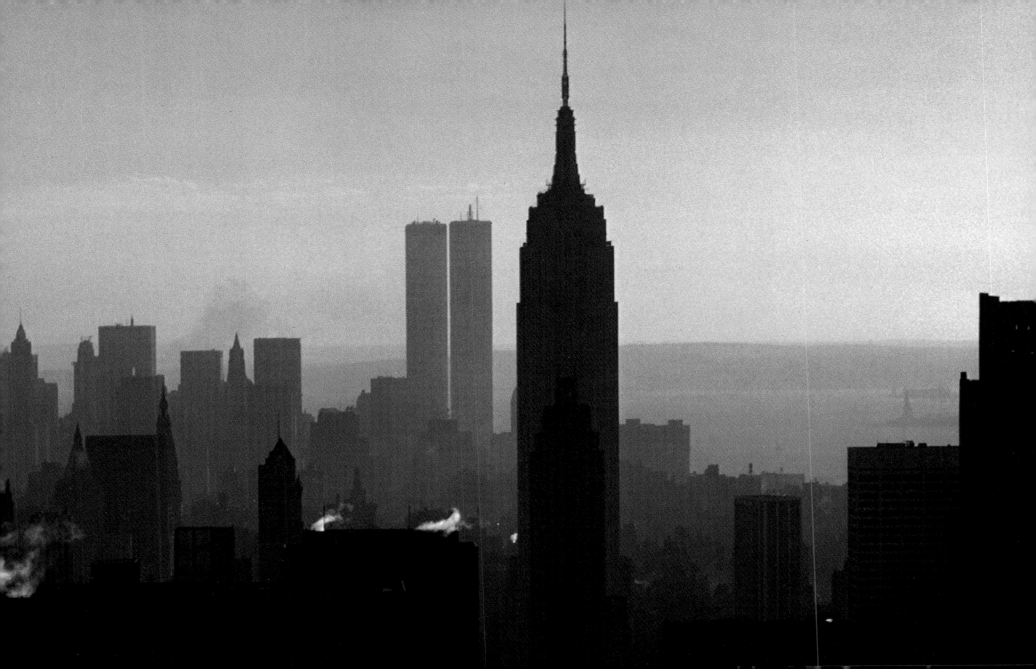

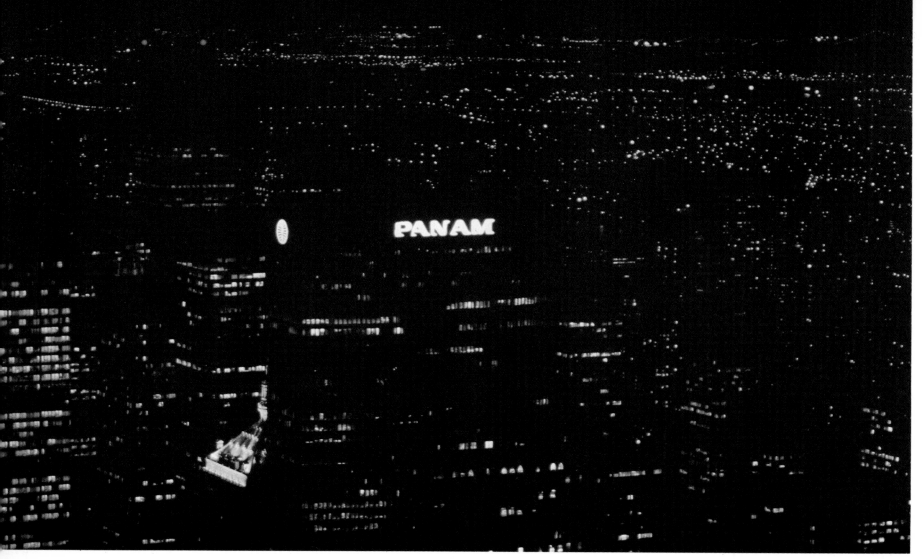

42 Pan Am Building

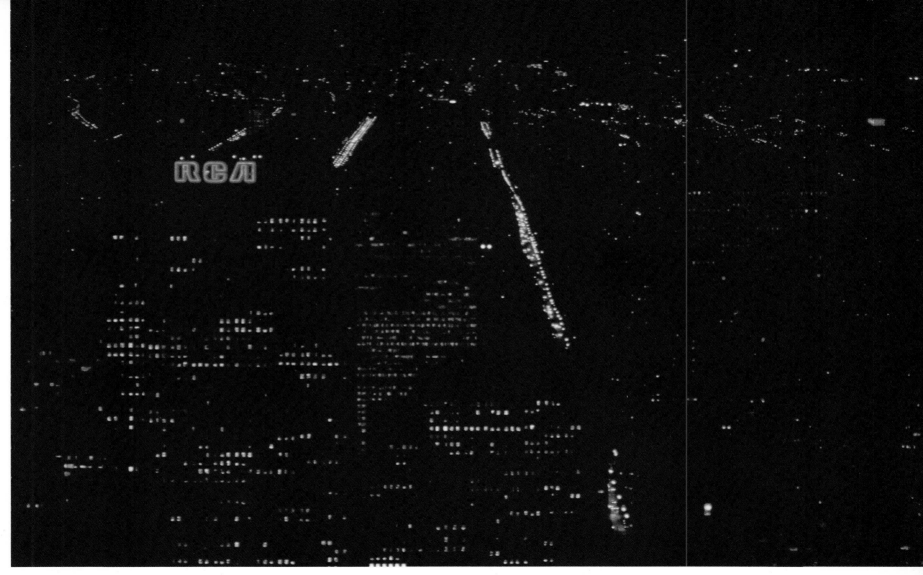

43　RCA Building

44 City Lights/Williamsburg Bridge

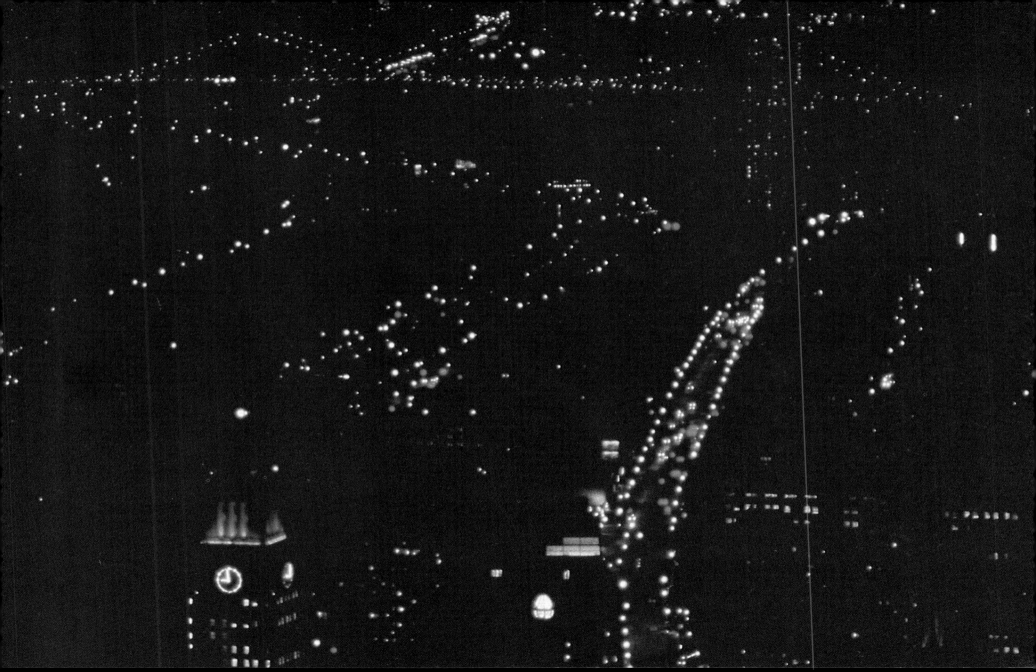

PART IV

CENTRAL PARK

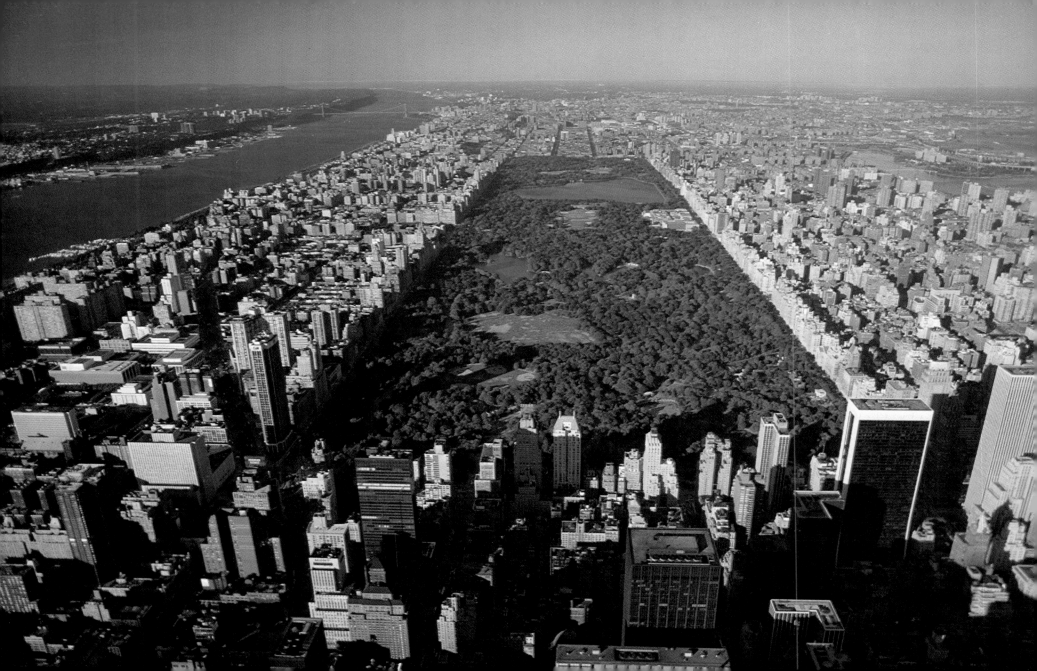

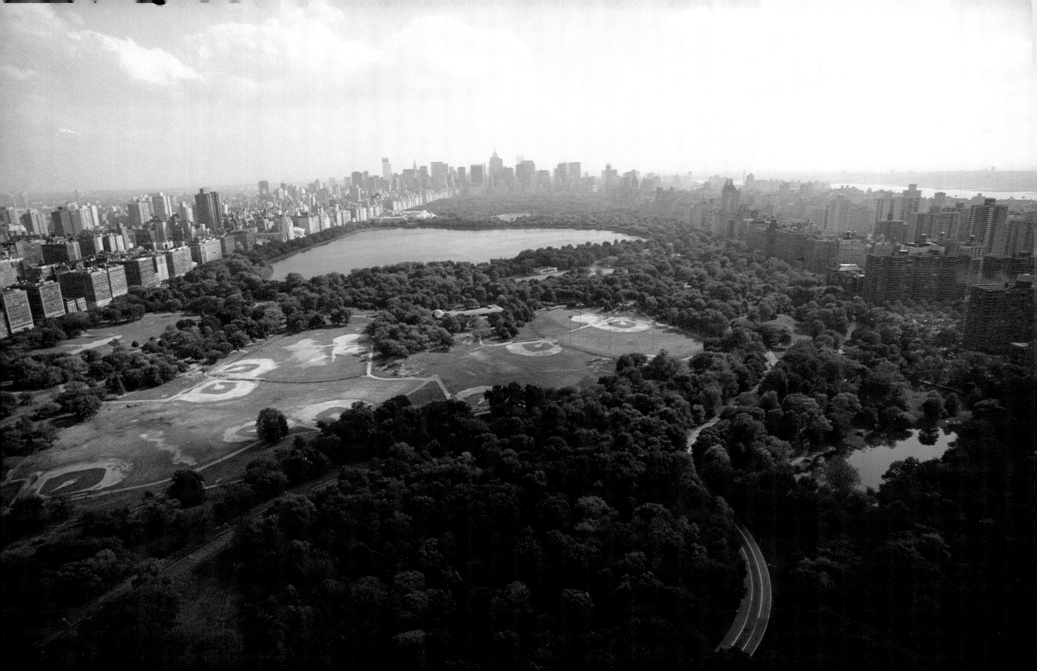

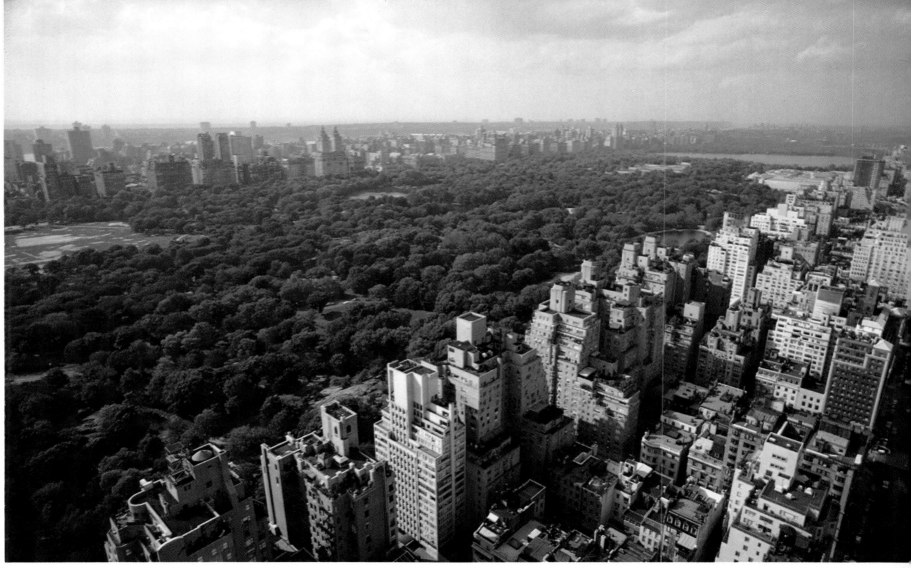

46–47 Central Park/East Side

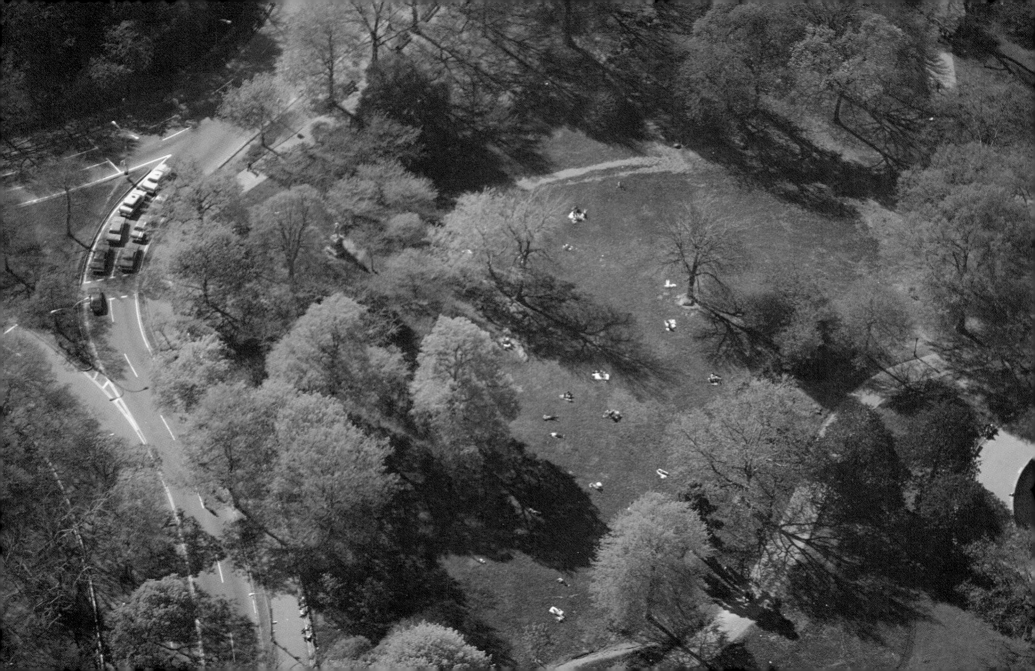

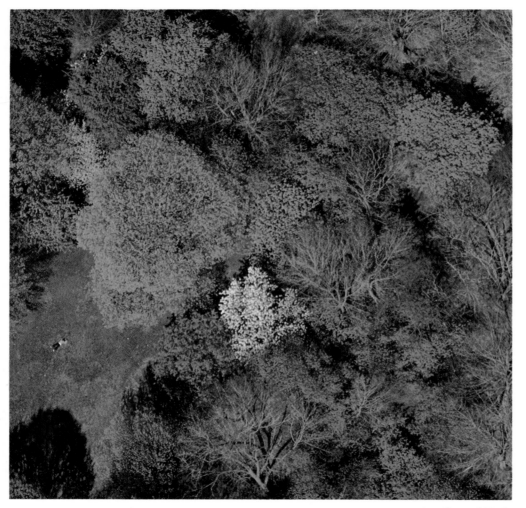

50 Central Park

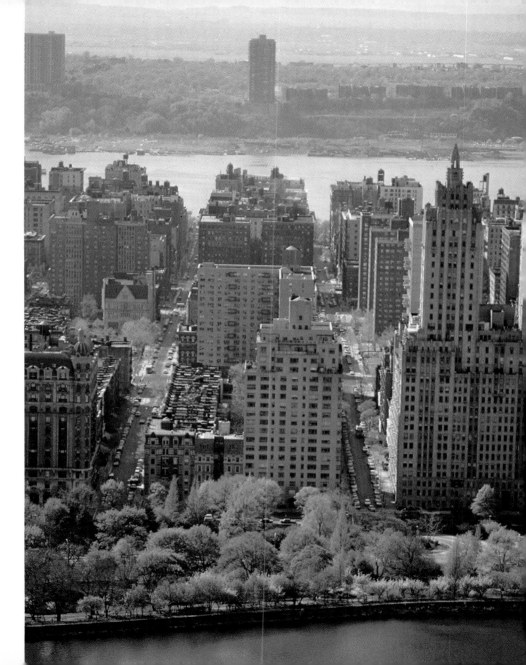

51 Receiving Reservoir/West Side

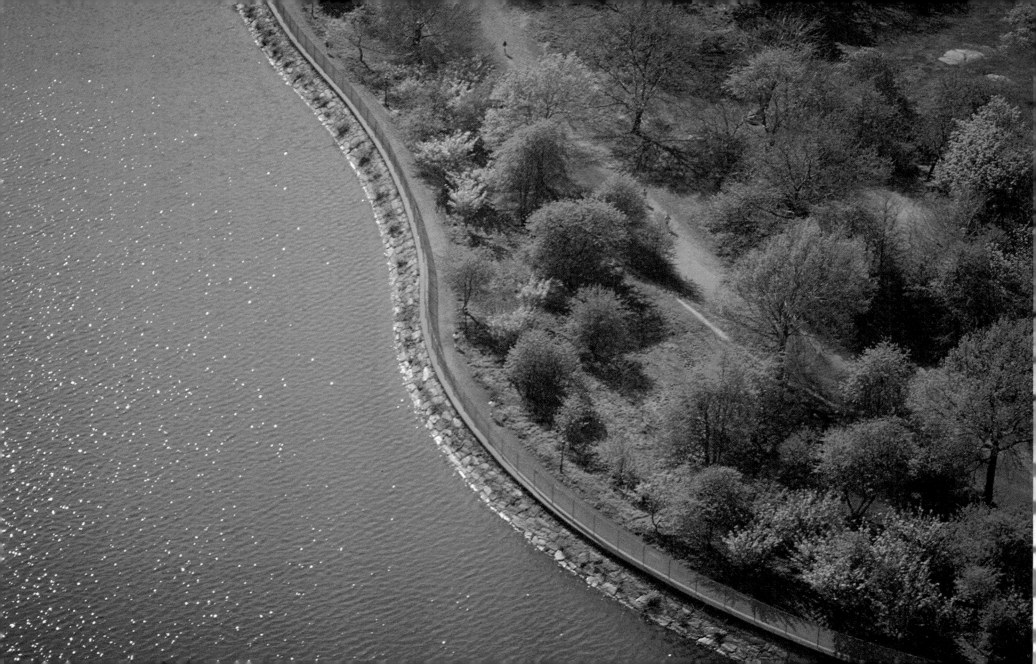

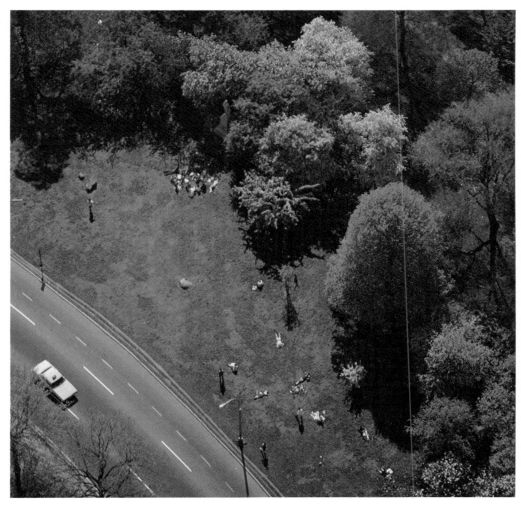

52 Receiving Reservoir/joggers

53 East Drive

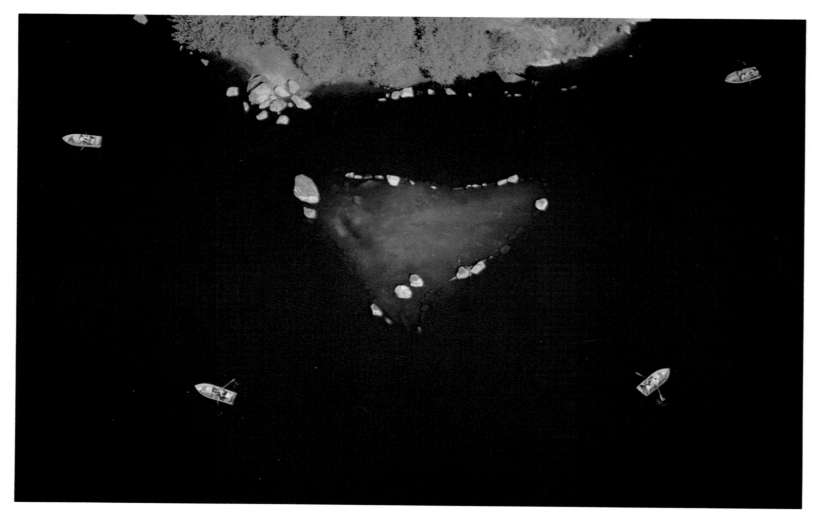

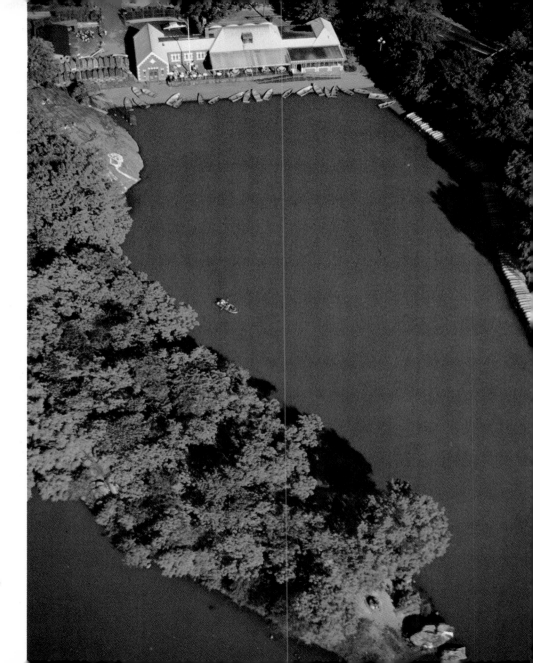

55 Loeb Boat House

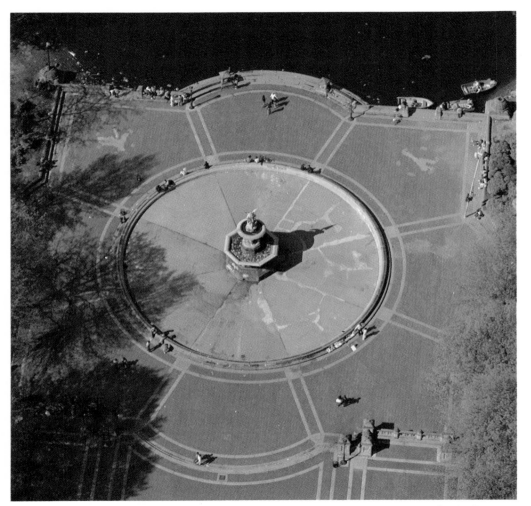

56 Bethesda Fountain

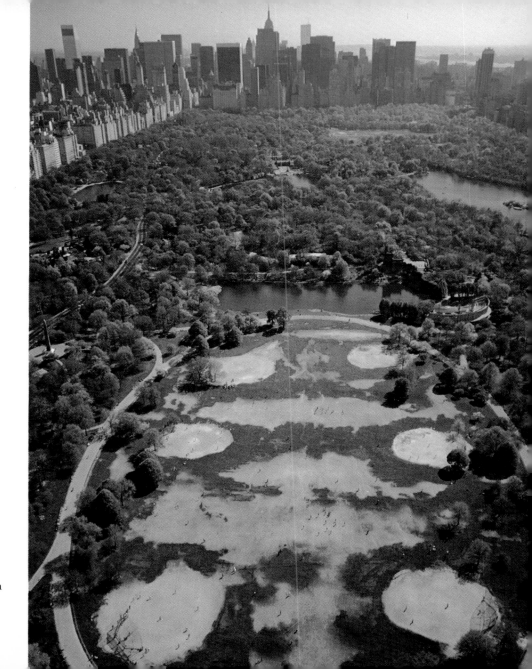

57 The Great Lawn

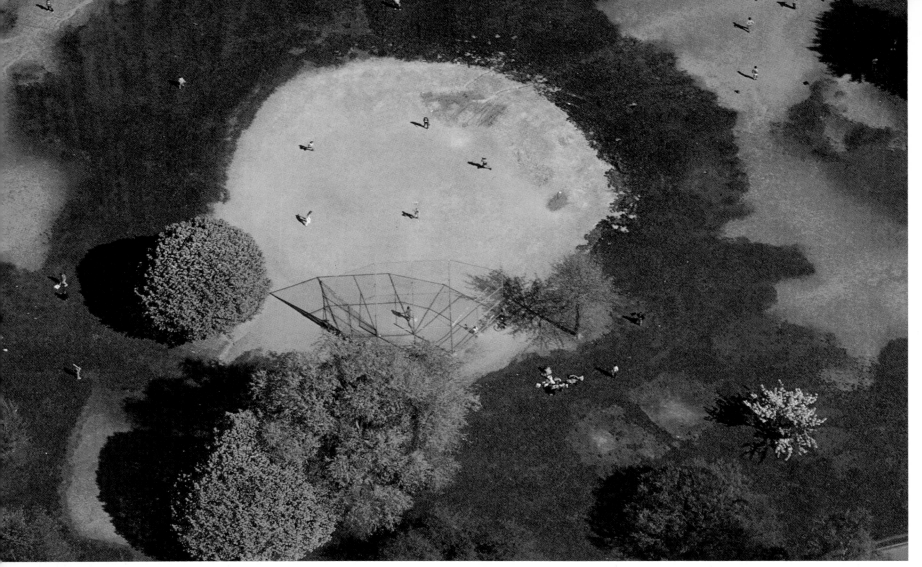

58 Central Park /softball game

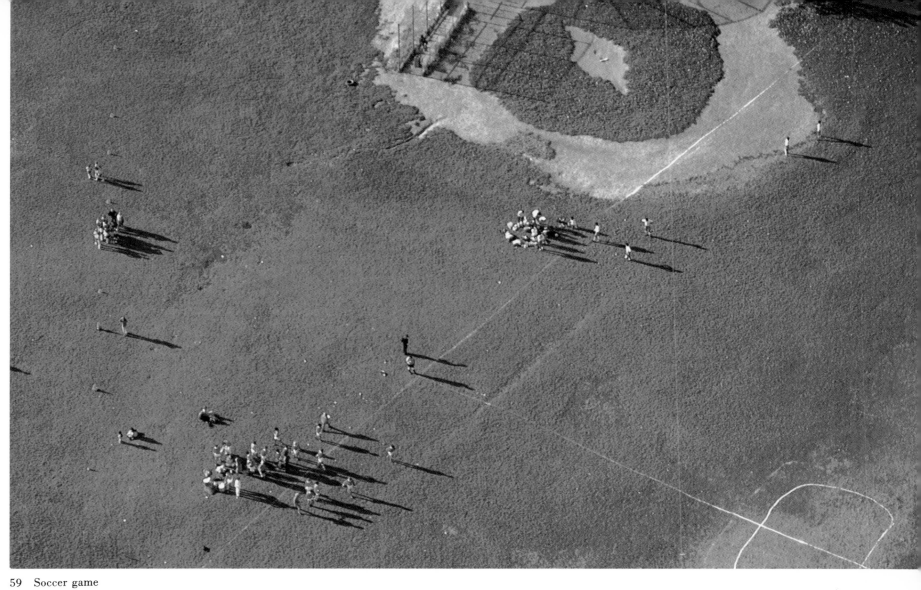

59 Soccer game

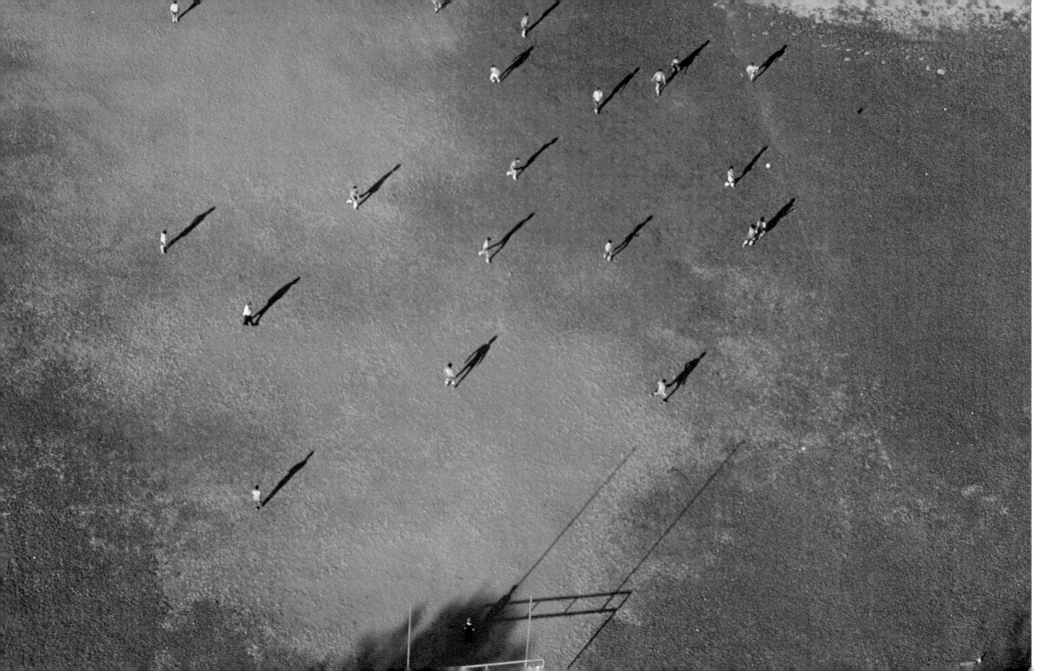

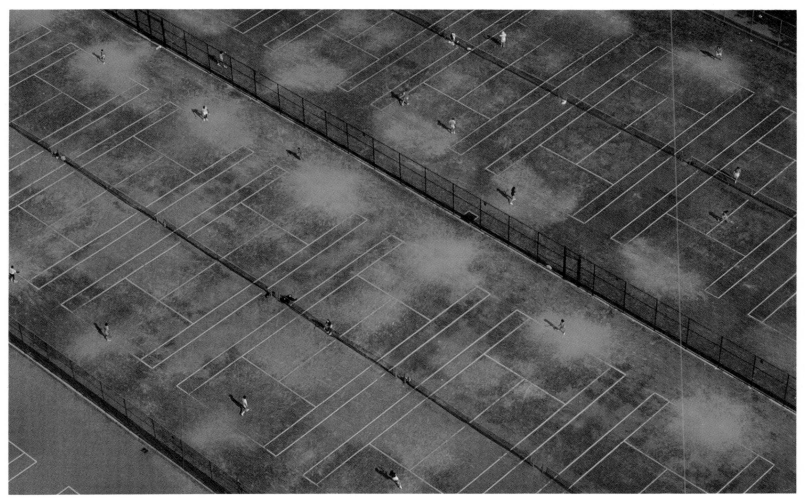

◁ 60 Central Park/soccer game
 61 Central Park/tennis courts

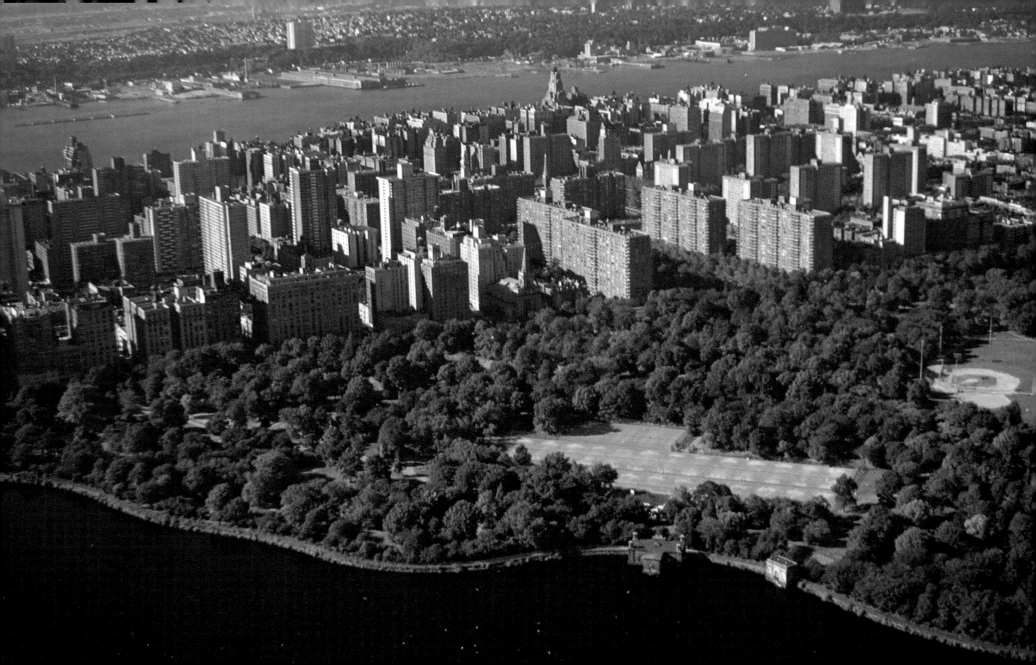

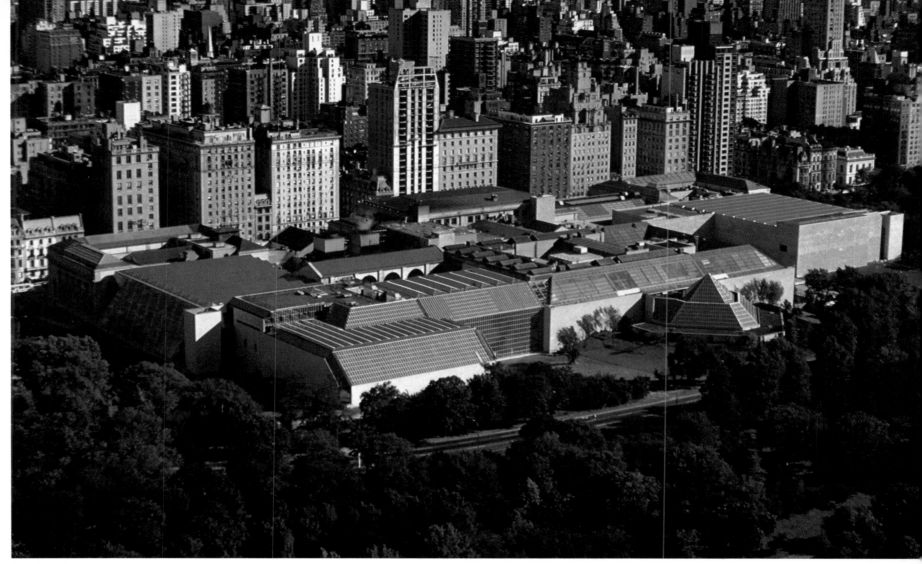

◁ 62 Tennis courts and West Side
63 Metropolitan Museum of Art

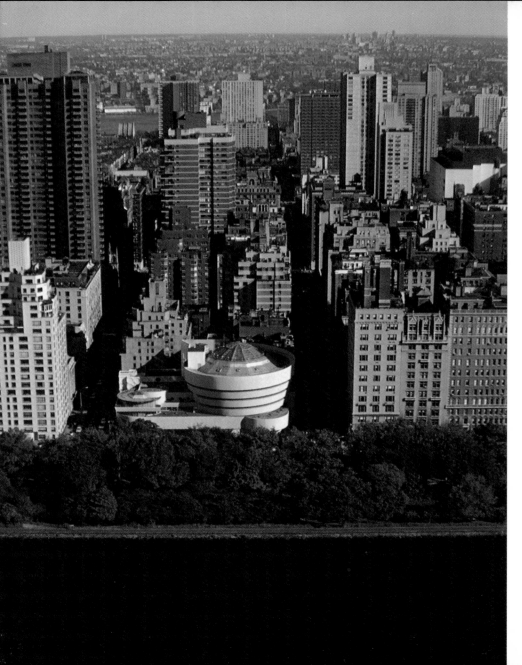

64 Guggenheim Museum

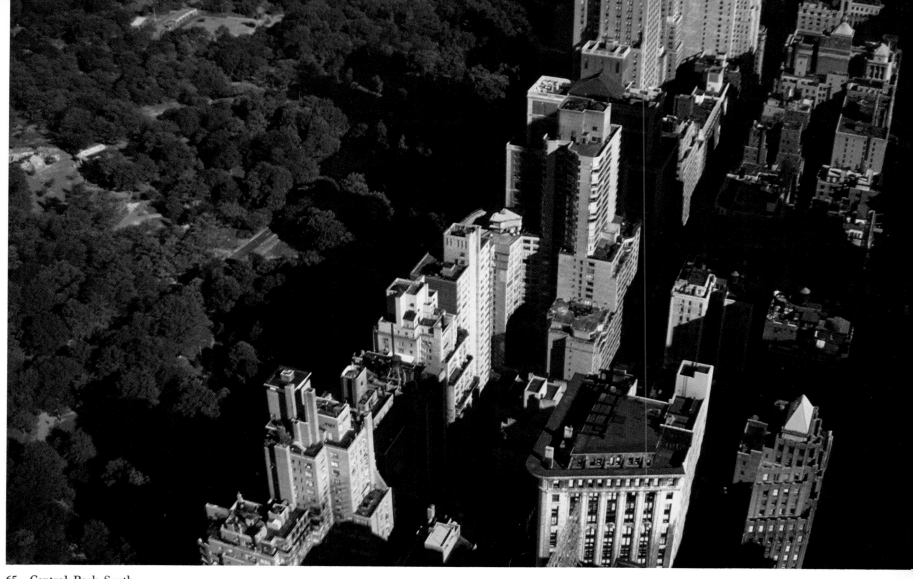

65 Central Park South

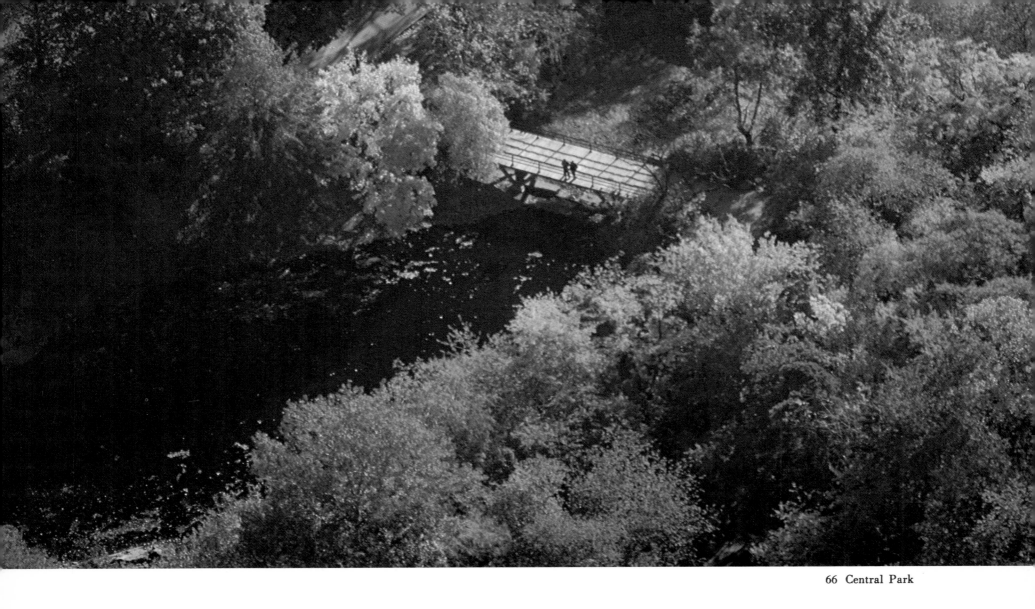

66 Central Park

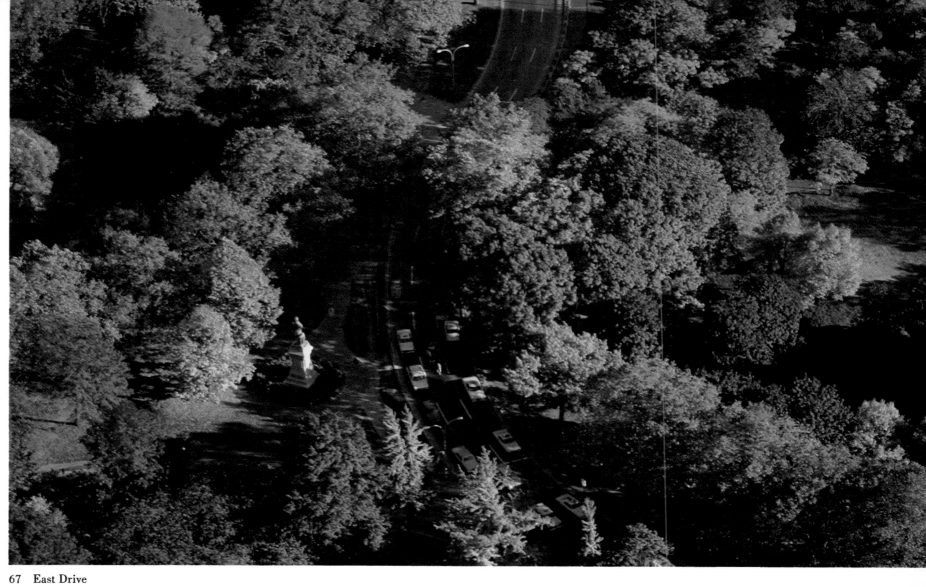

67 East Drive

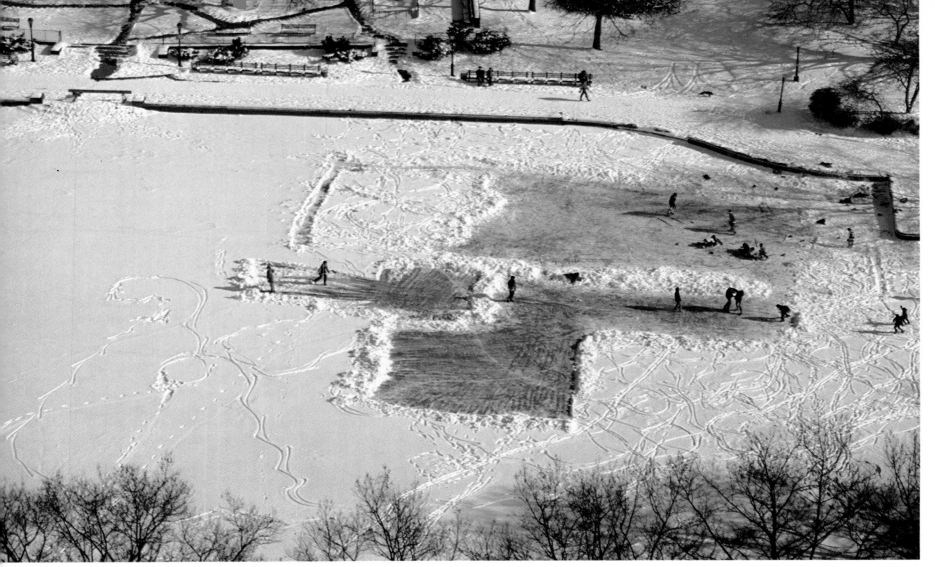

68 Conservatory Pond
69 Cross-country skiing ▷

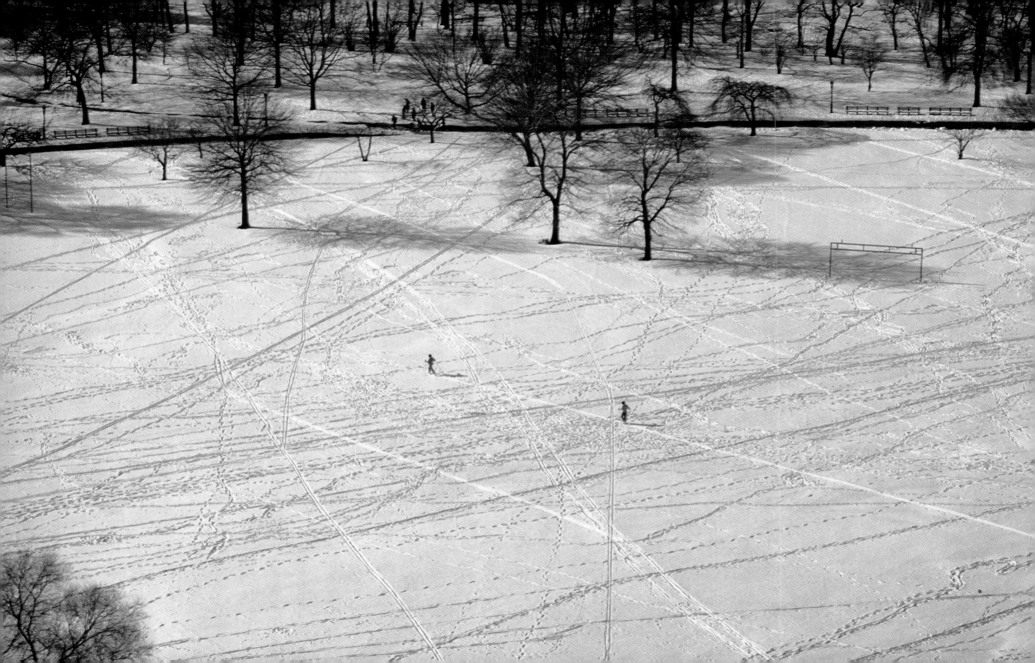

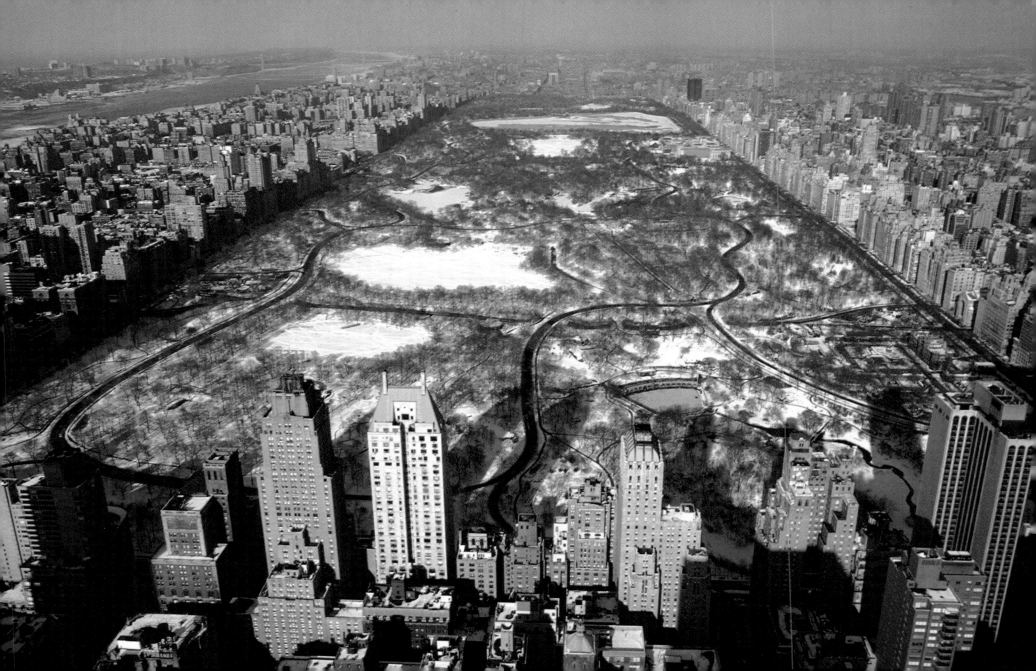

EAST SIDE
HARLEM RIVER

71 East Side/sunbather

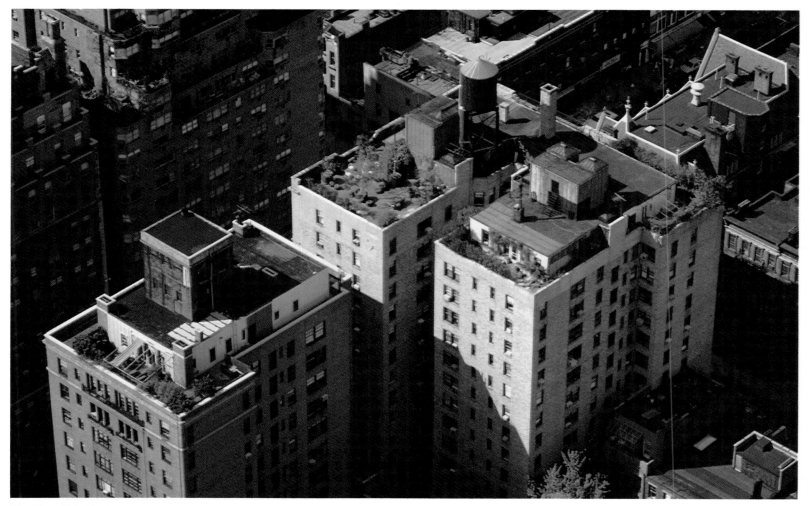

◁ 72 East Side/jogger
73 Lexington Avenue near Twenty-eighth

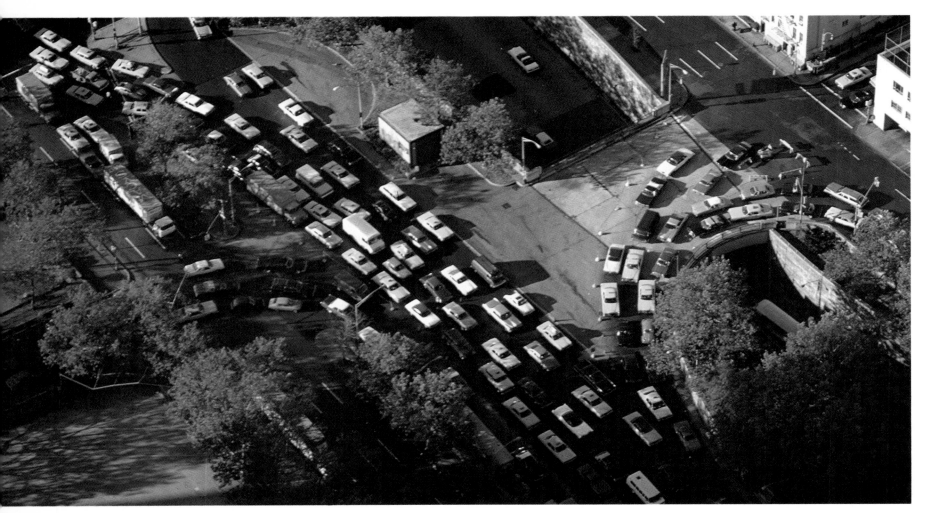

74 Queens–Midtown Tunnel entrance at East Thirty-sixth Street

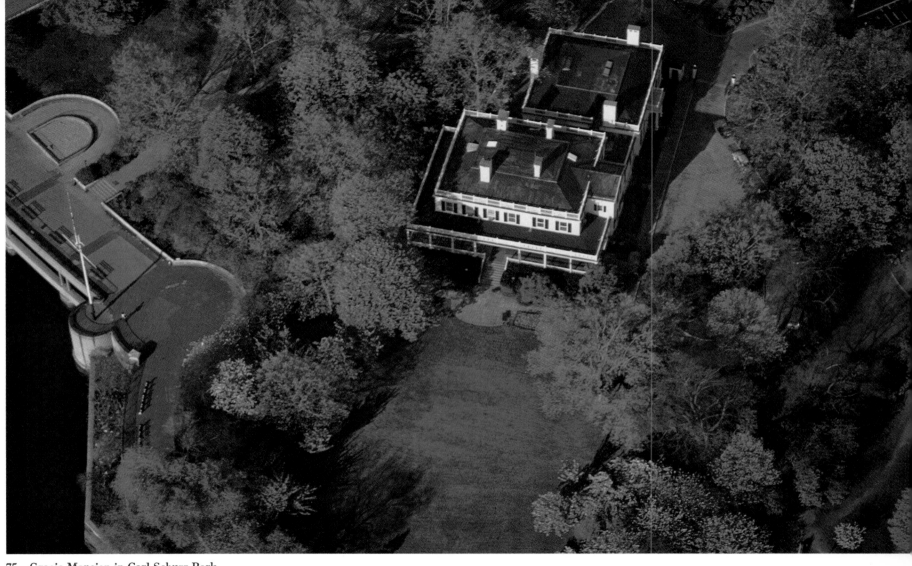

75 Gracie Mansion in Carl Schurz Park

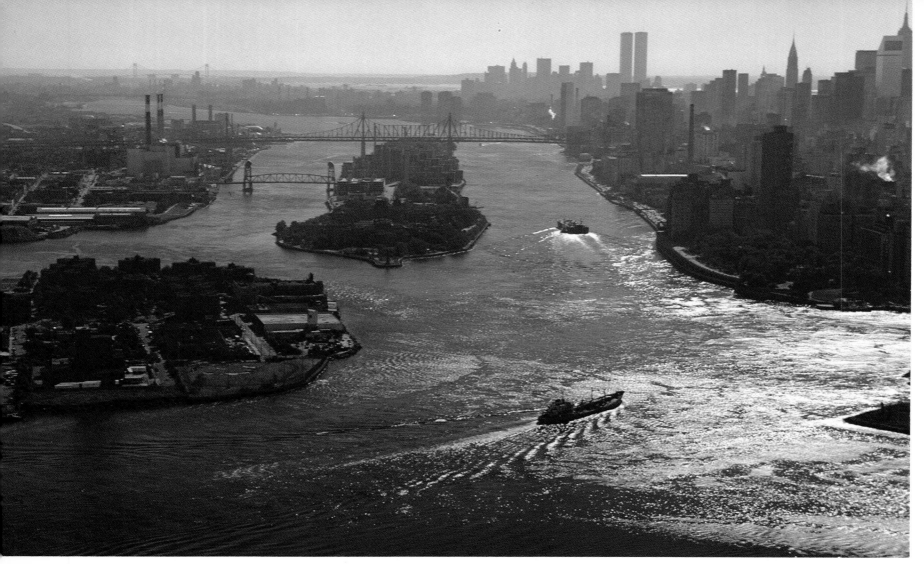

76 Wards Island/East River
77 Harlem River and Triborough Bridge ▷

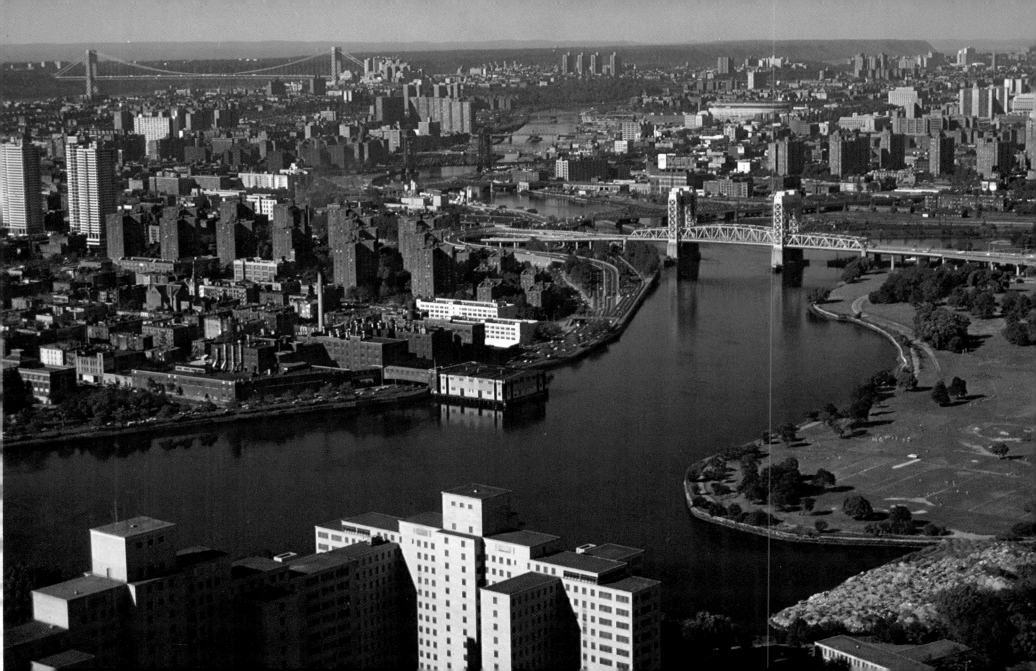

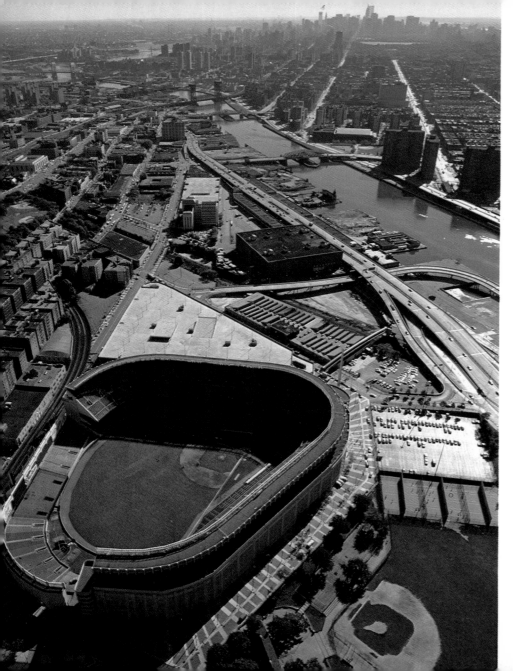

78 Yankee Stadium 79 Harlem River

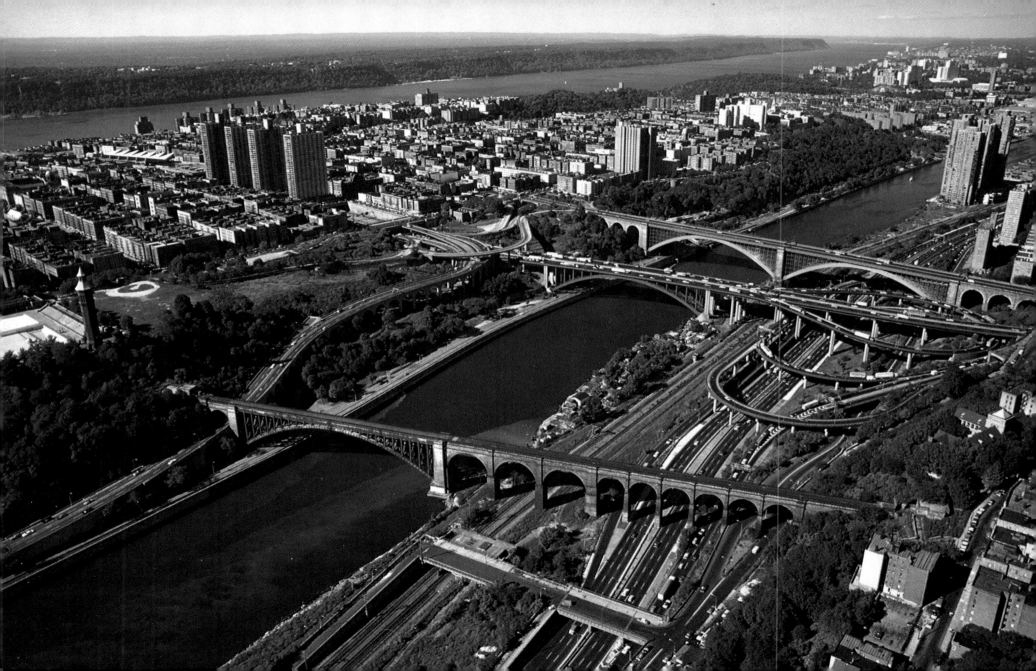

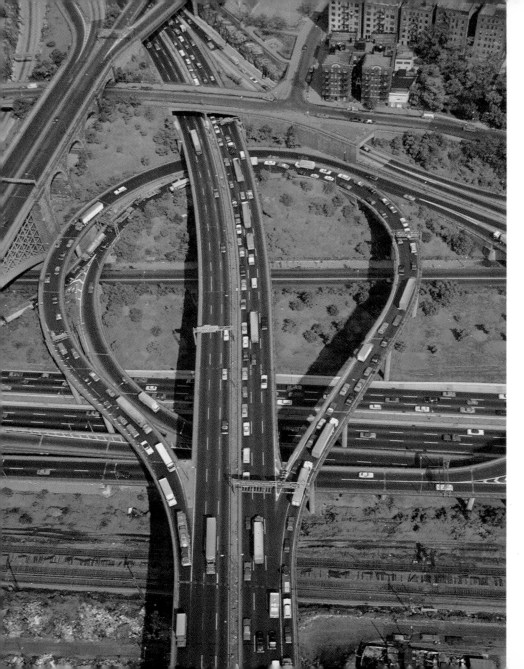

80 Major Degan and Cross Bronx Interchange

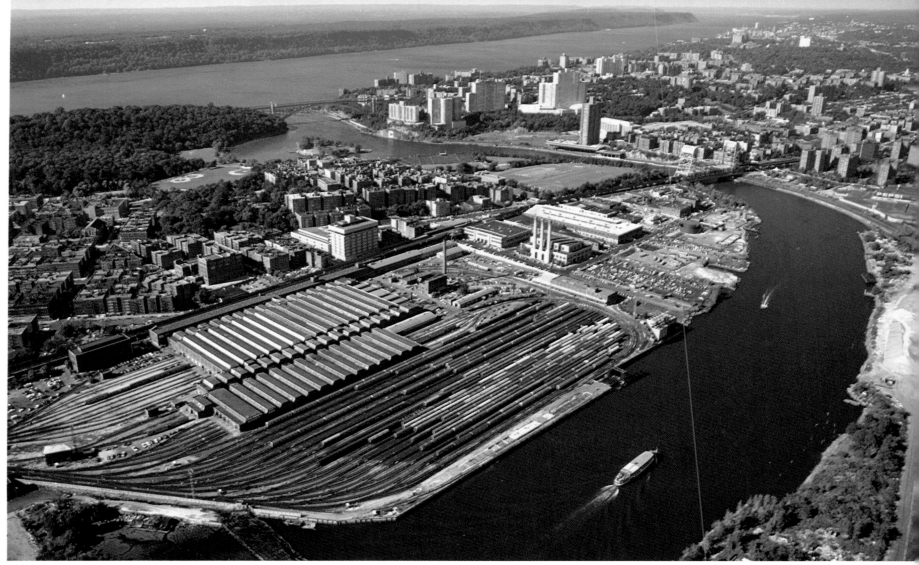

81 Tip of Upper Manhattan

UPPER AND LOWER MANHATTAN
THE WEST SIDE

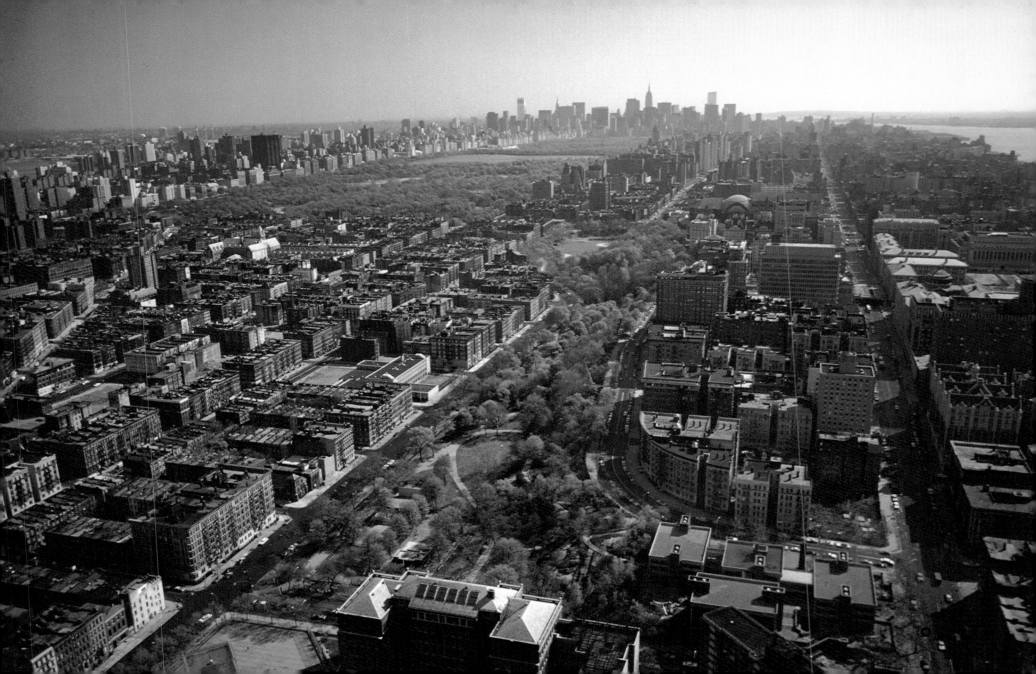

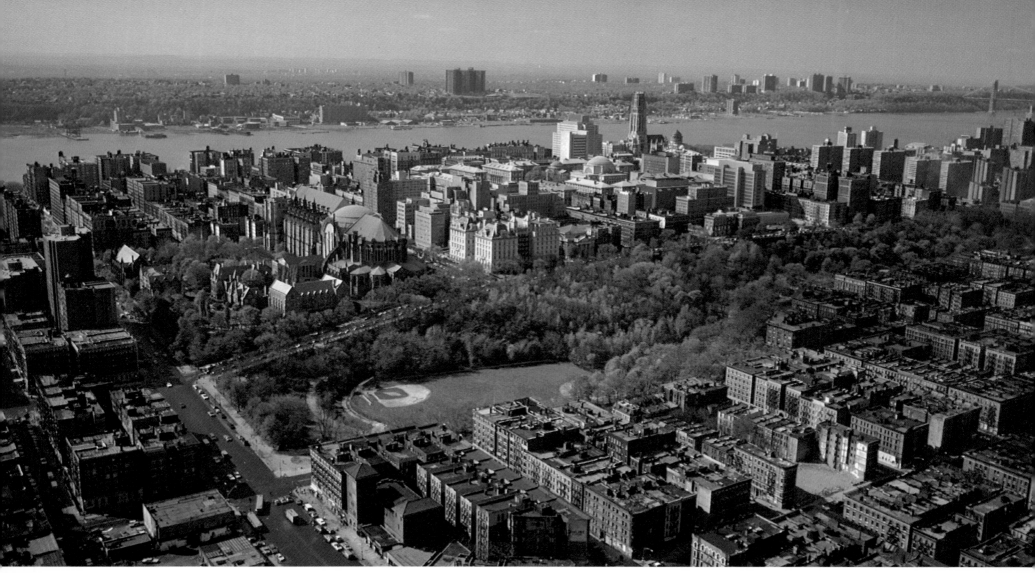

83 Morningside Park and Columbia University

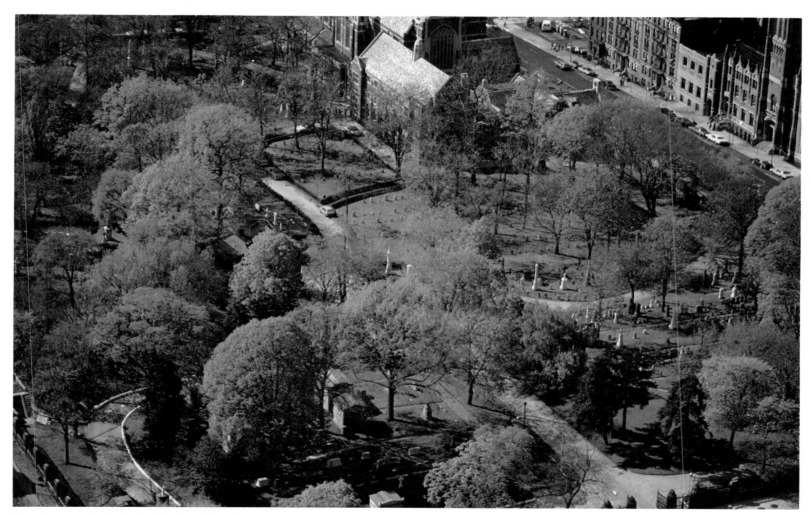

84 Cemetery/Cathedral of St. John The Divine

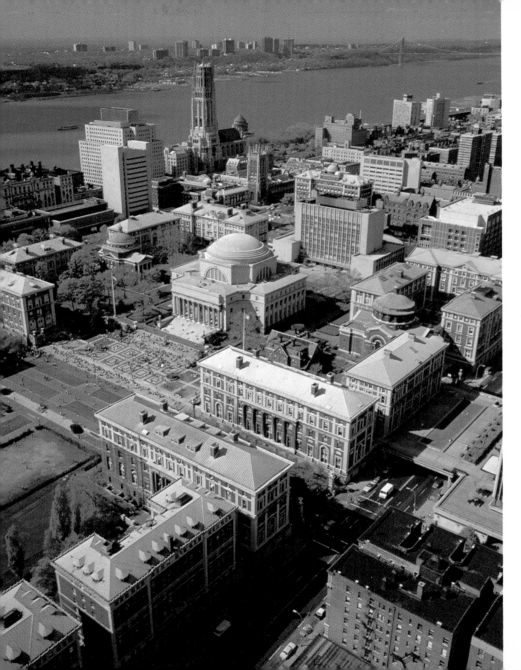

85 Columbia University

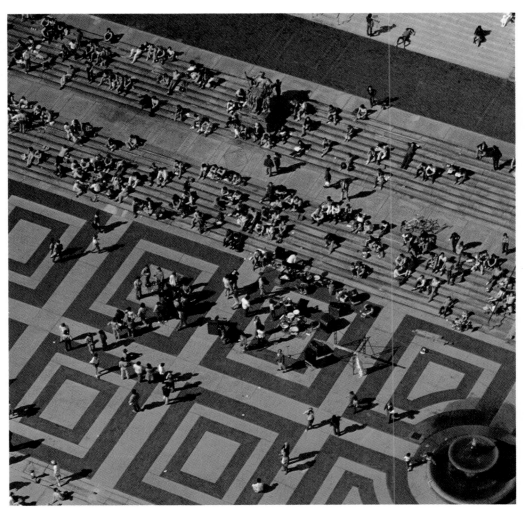

86 Low Memorial Library steps

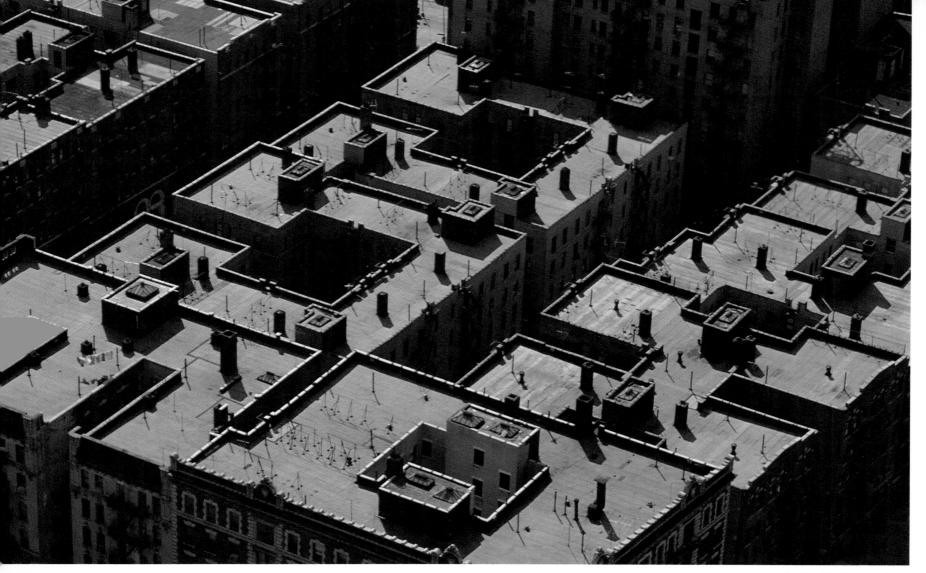

87 Harlem rooftops
88 Harlem rooftop playground ▷

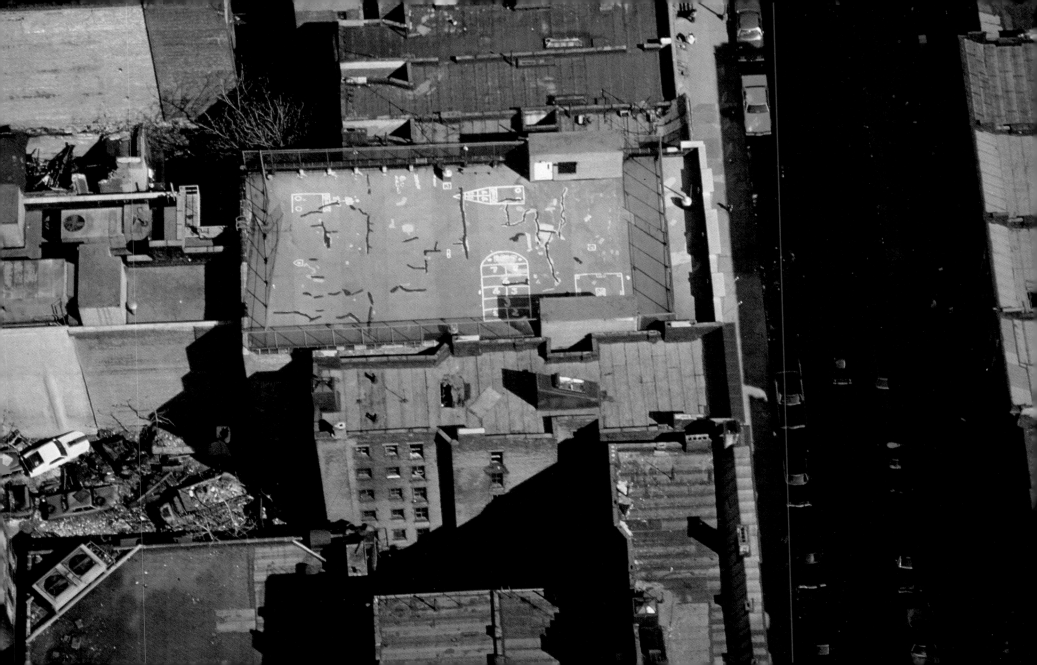

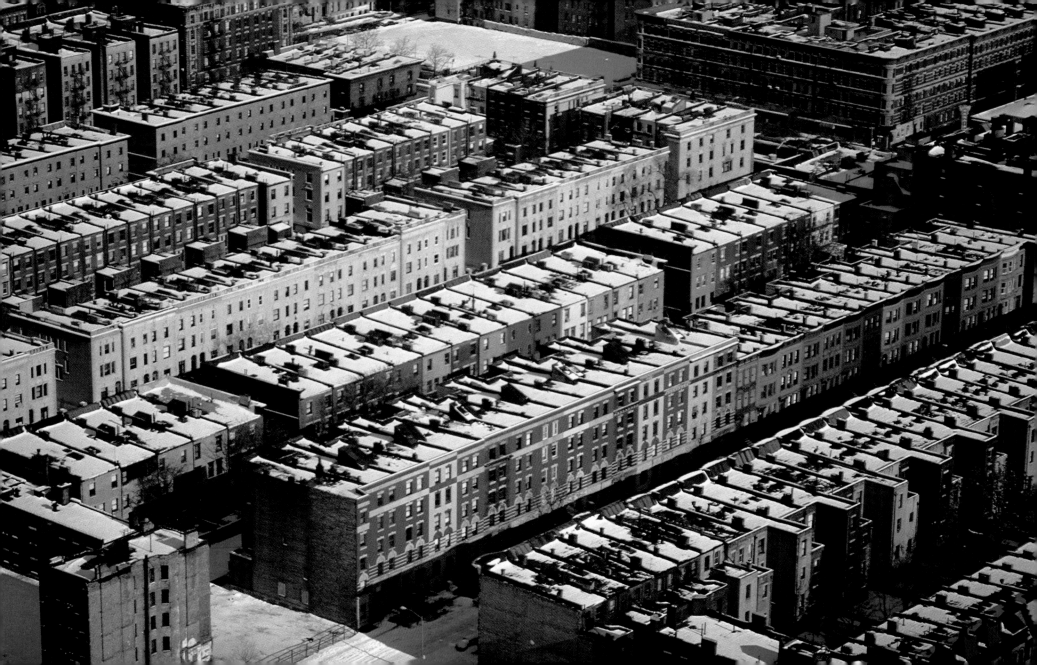

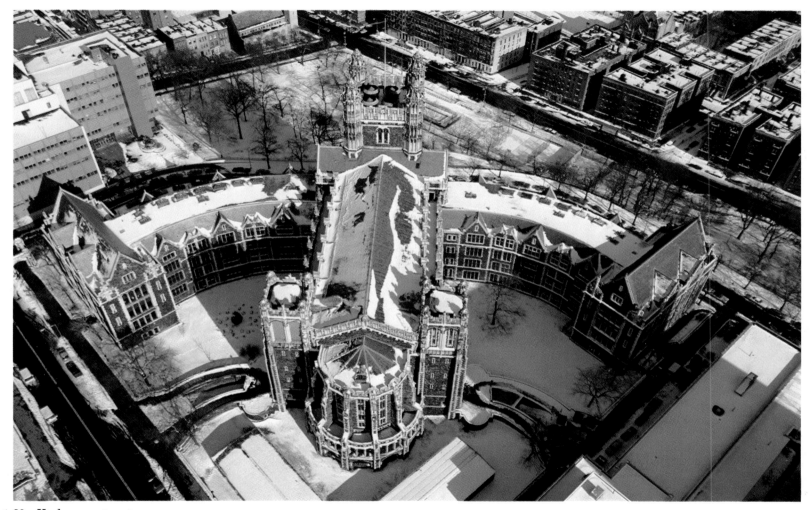

89 Harlem apartments
90 Union Theological Seminary

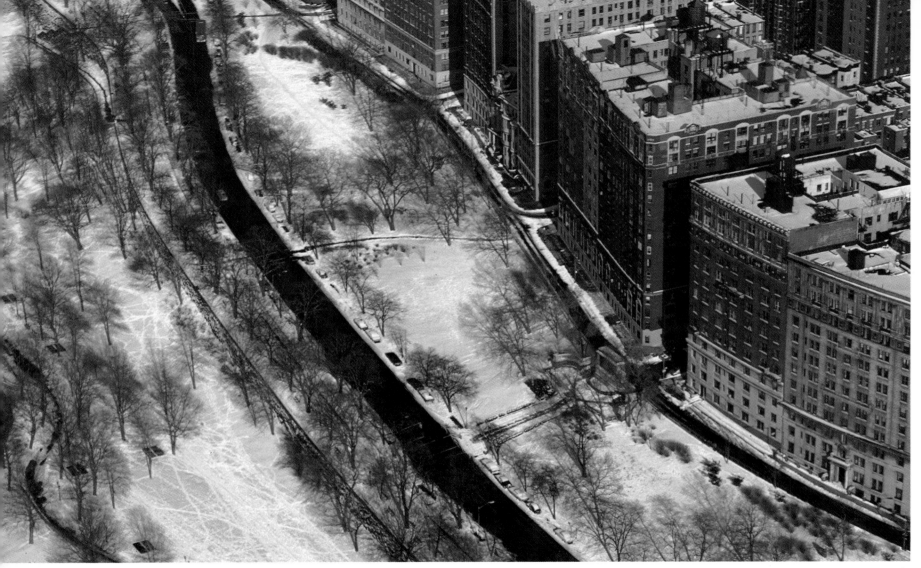

91 Riverside Drive at 100th Street
92 Soldiers' and Sailors' Monument ▷

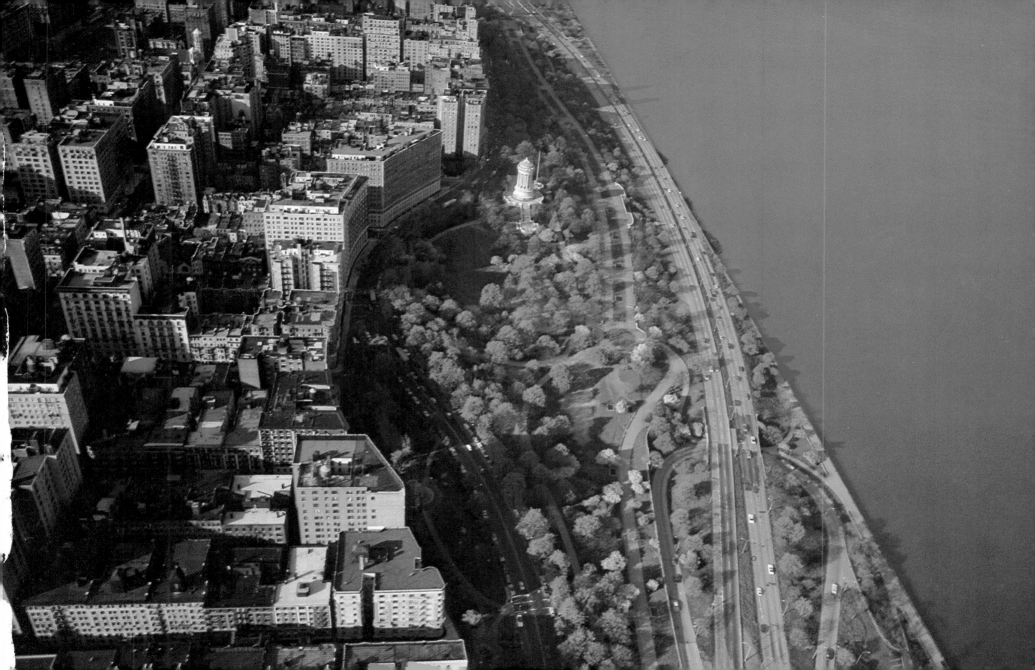

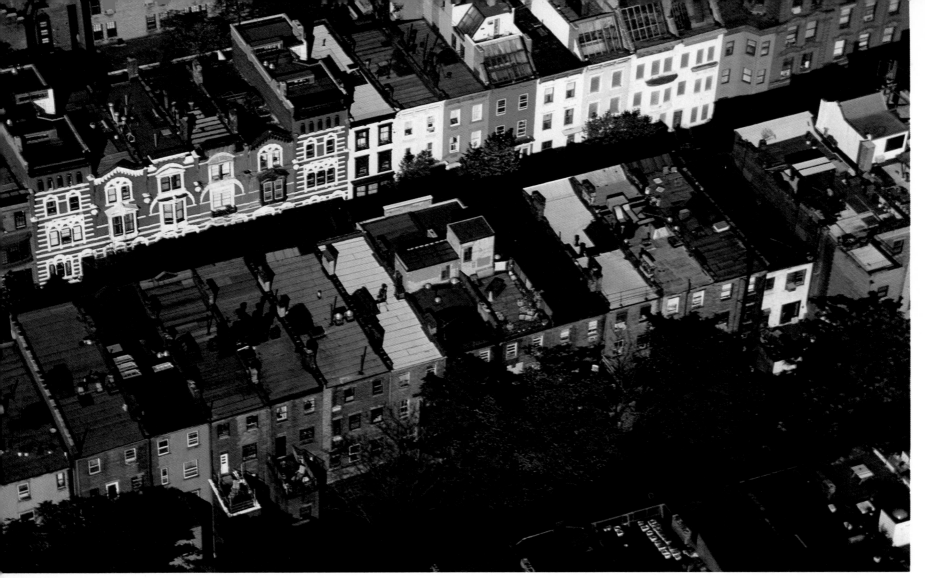

93 Row Houses in the West Seventies

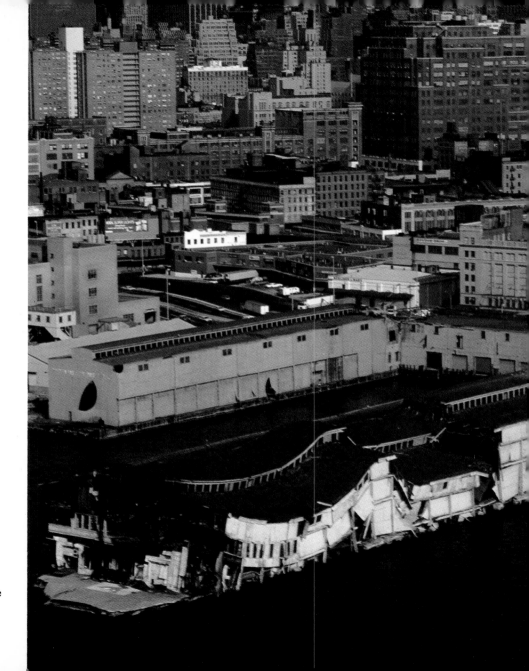

94 Dilapidated pier/West Side

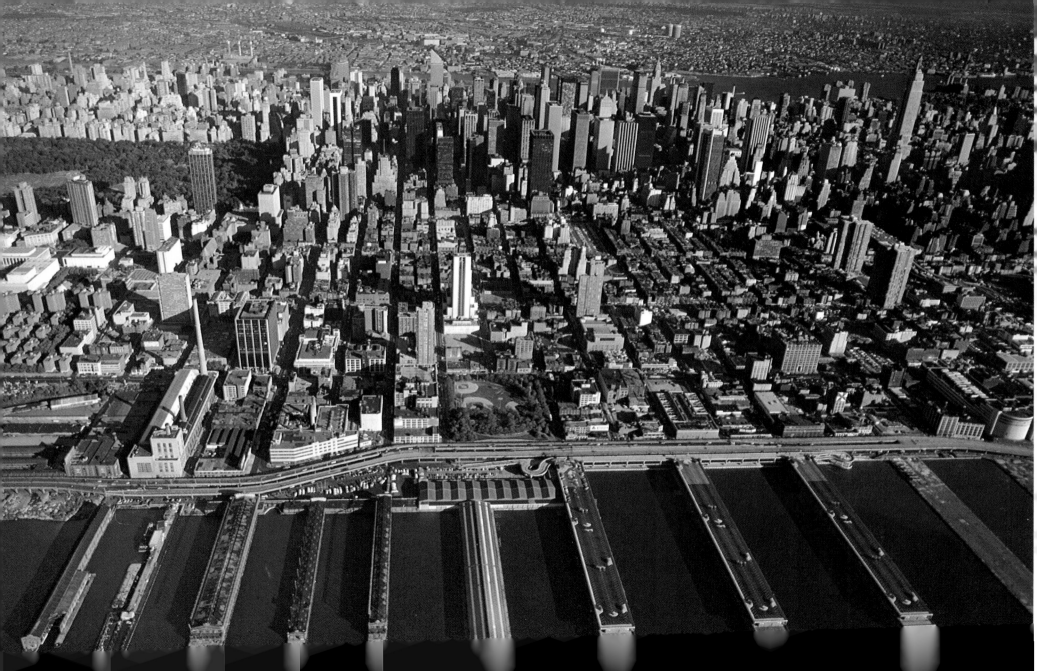

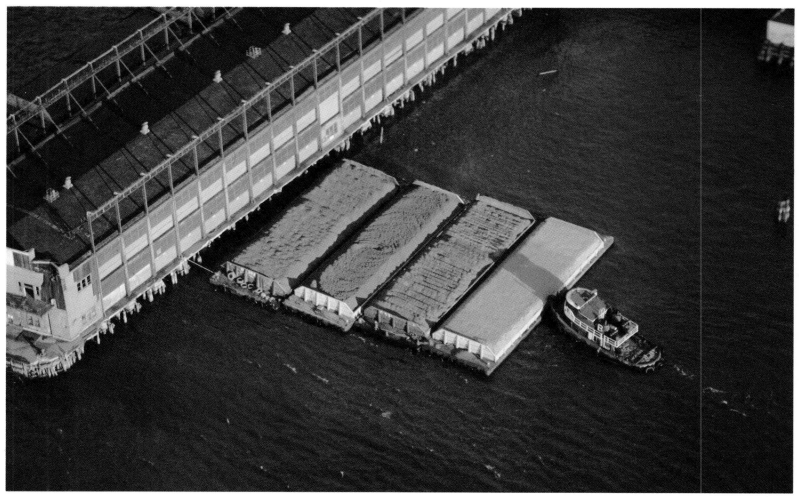

◁ 95 West Side piers
96 Gravel barges and tugboat

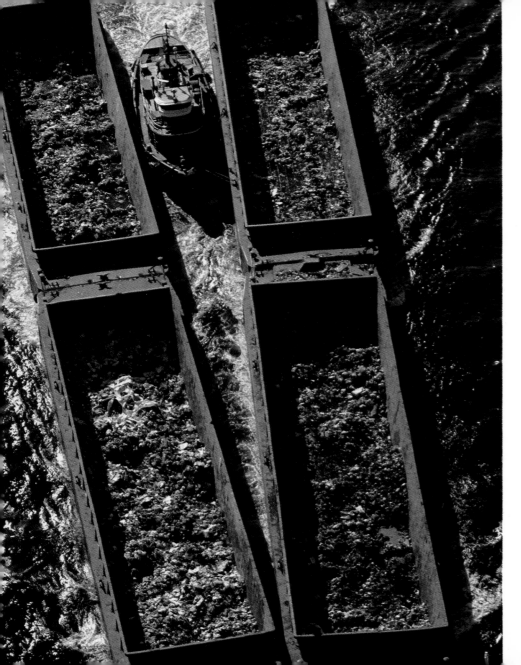

97 Garbage barges

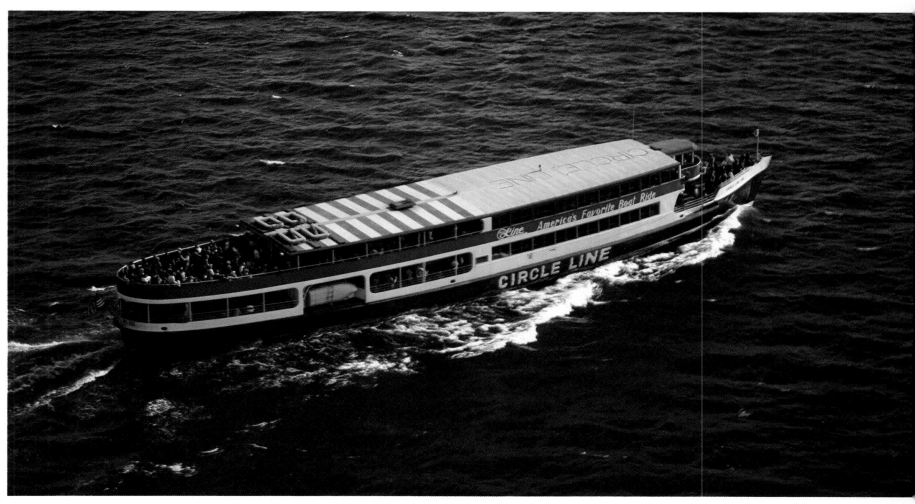

98 Circle Line boat tour

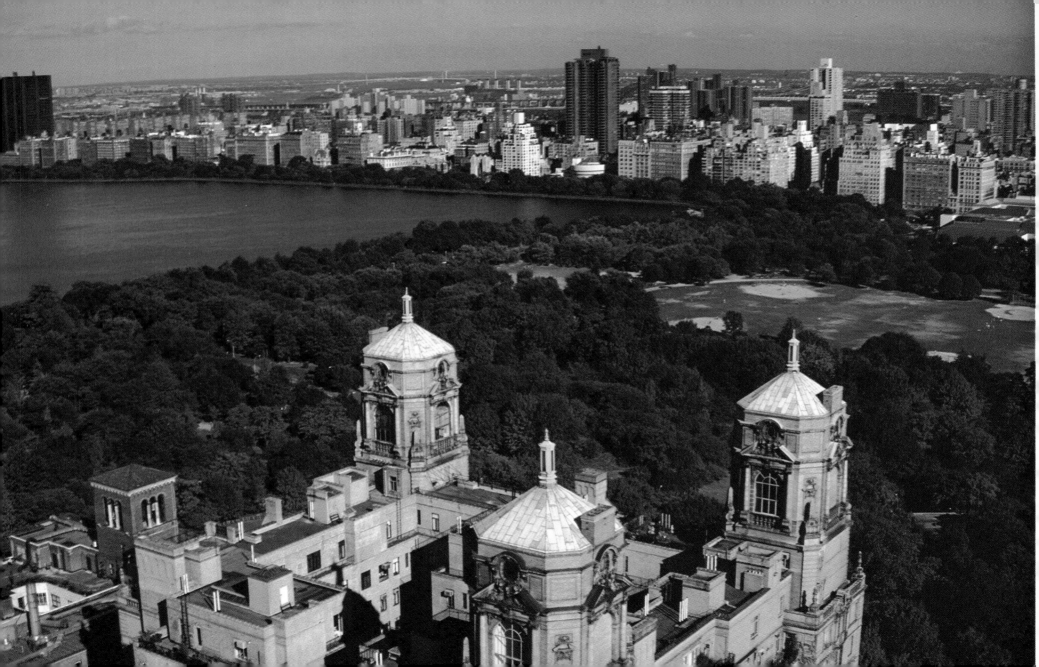

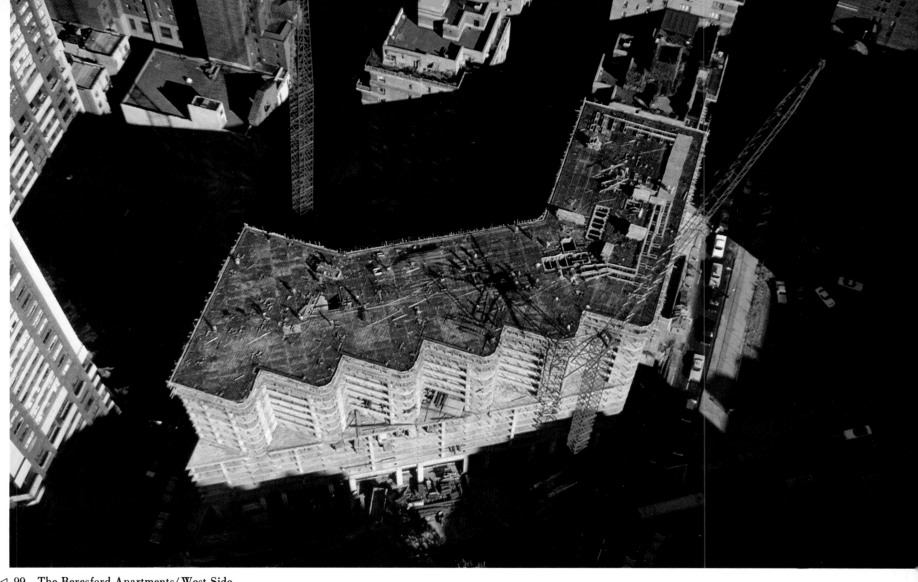

◁ 99 The Beresford Apartments/West Side
100 West Side/apartment construction

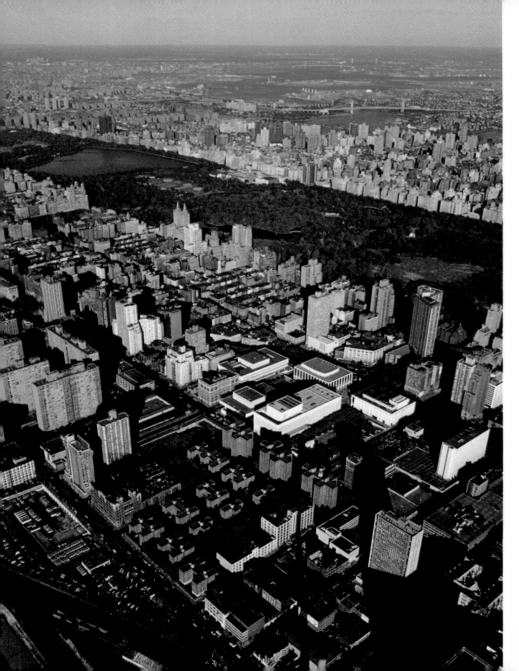

101 West Side/Lincoln Center 102 Upper East Side

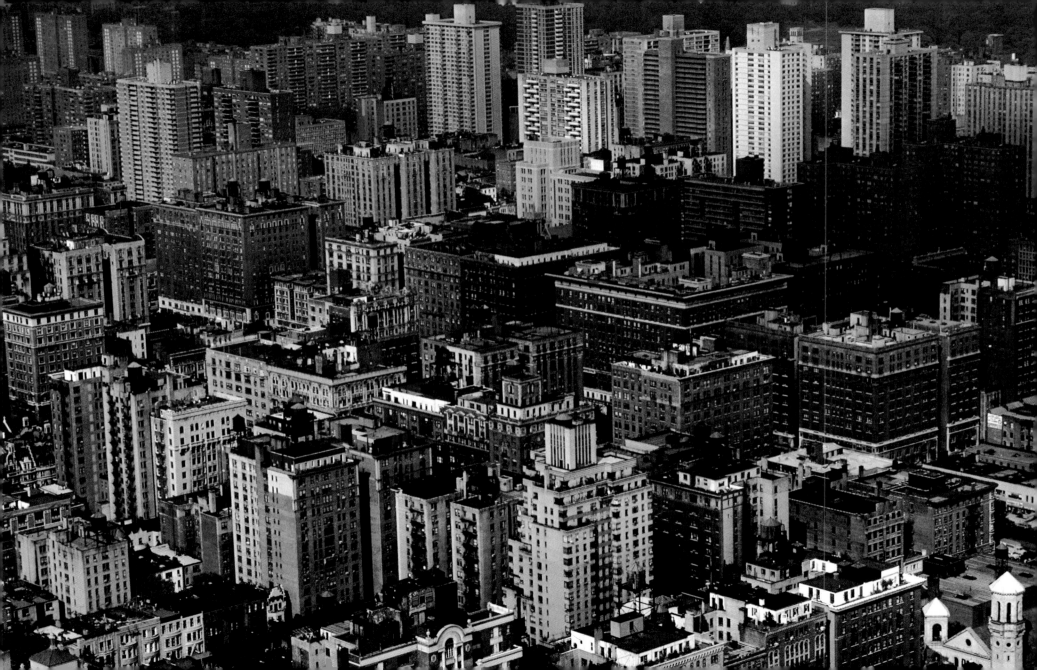

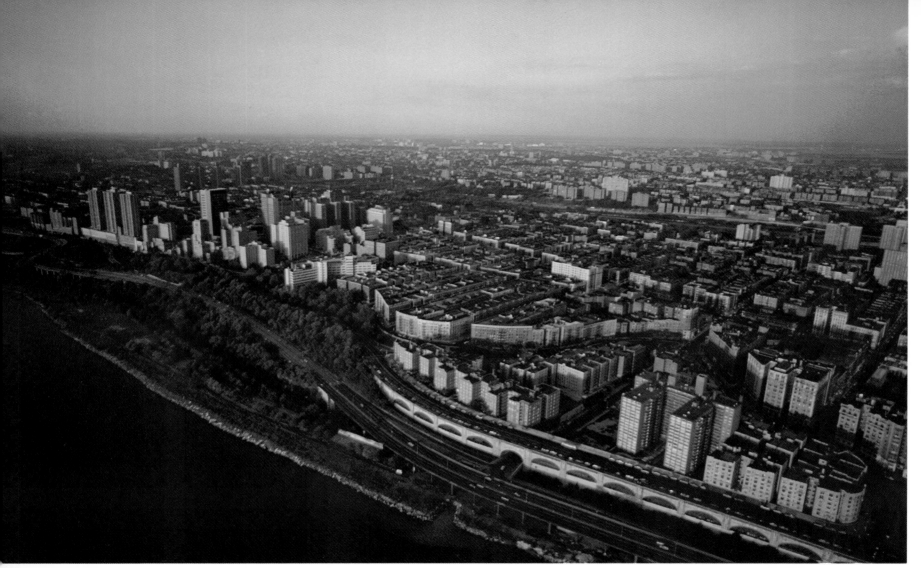

103 Upper Manhattan

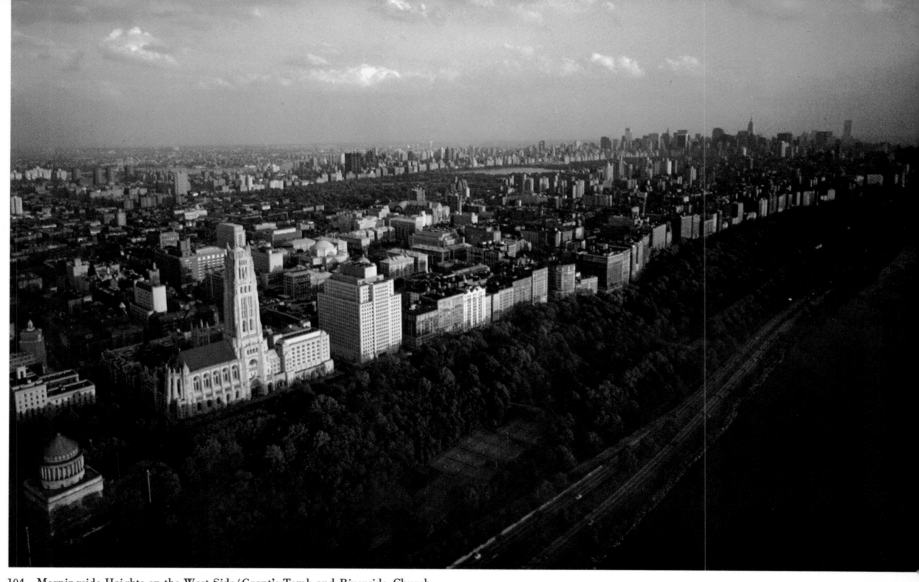

104 Morningside Heights on the West Side/Grant's Tomb and Riverside Church

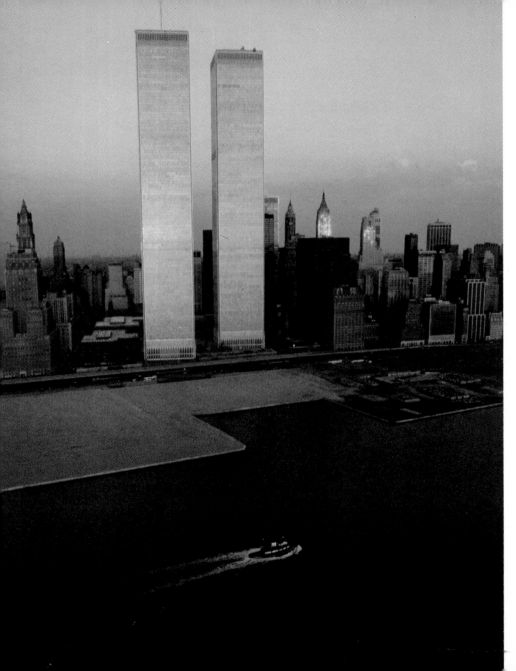

105 Hudson River/World Trade Towers

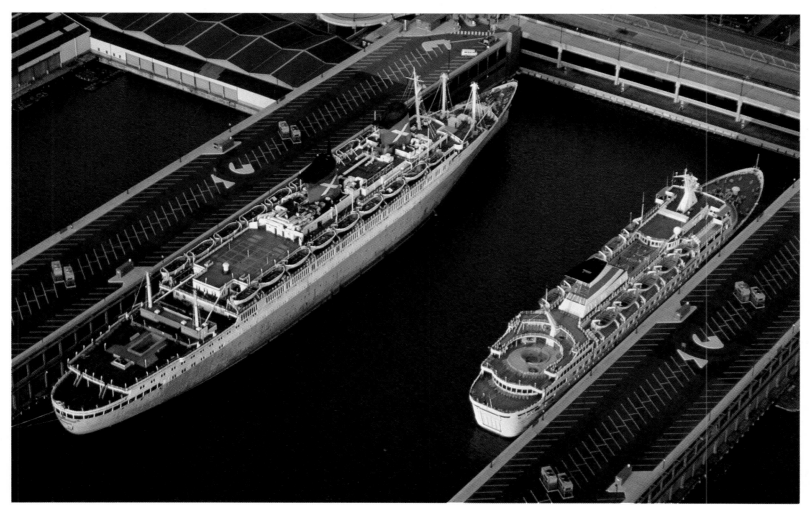

106 Passenger ships/West Side piers

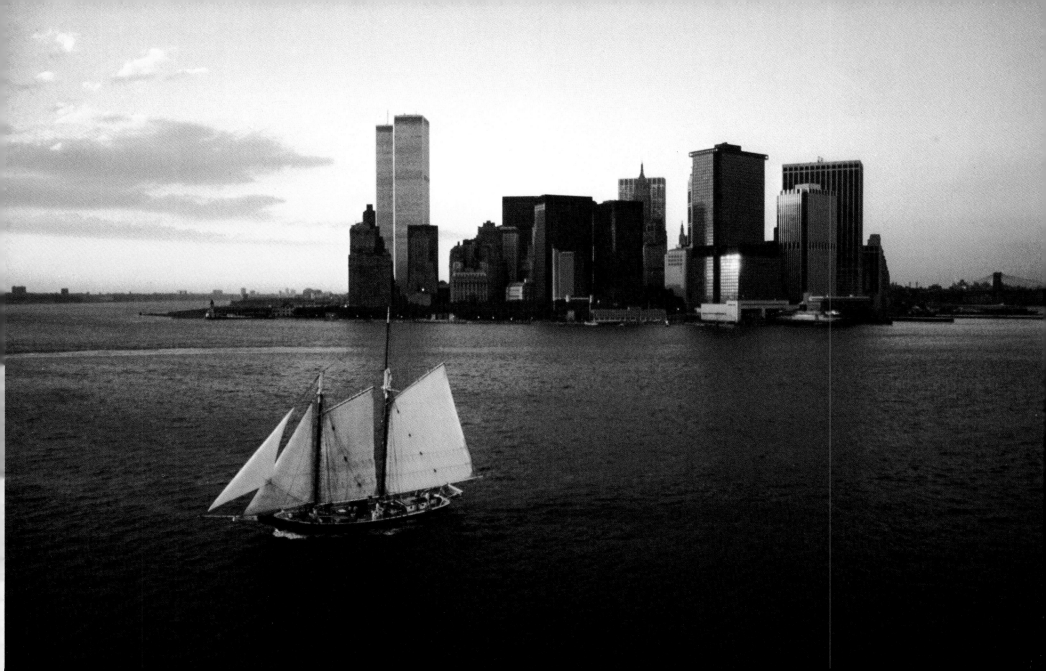

108 The financial district

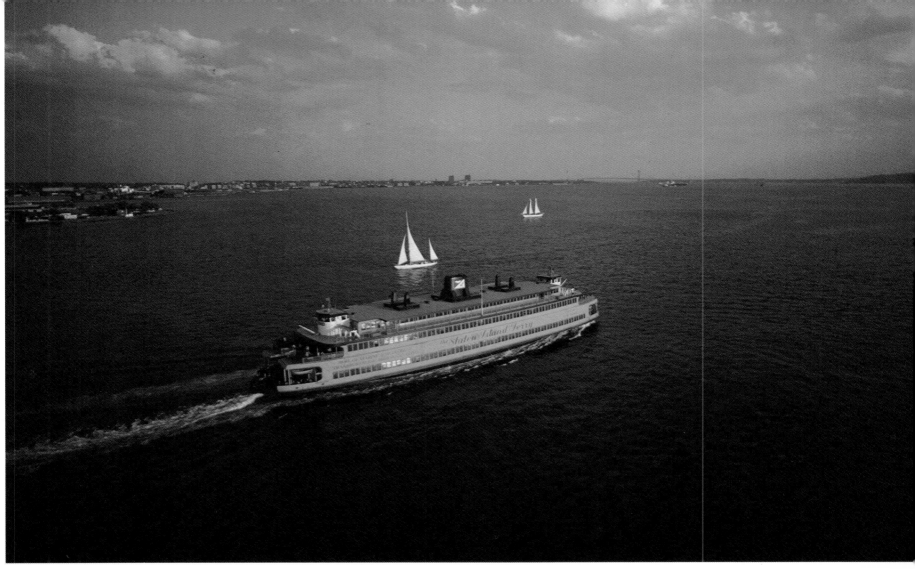

109 Staten Island Ferry/Upper Bay

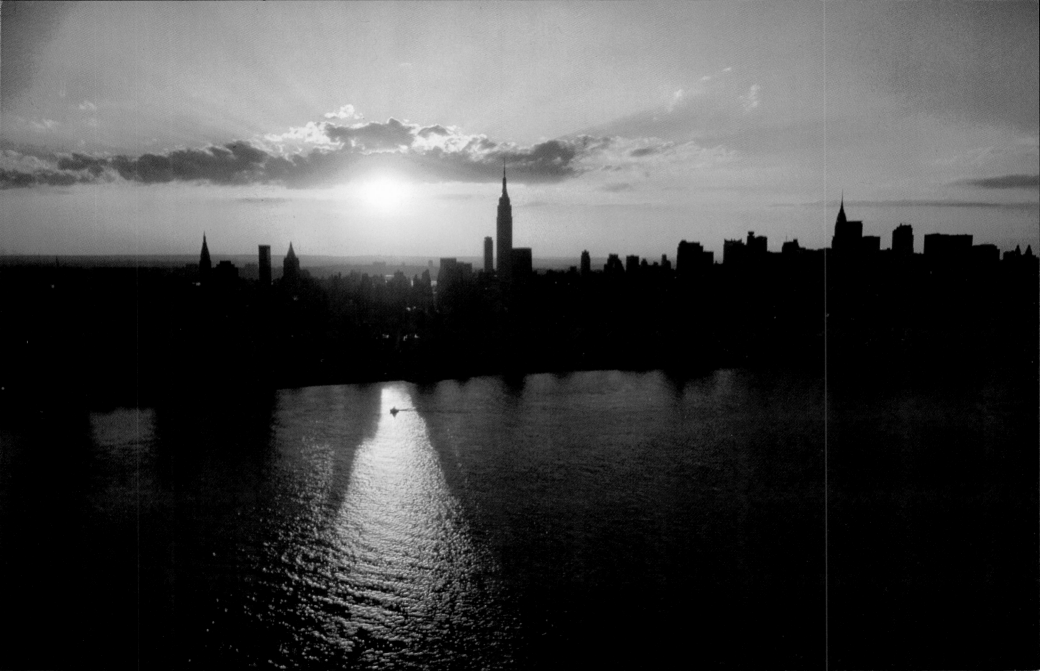

NOTES TO THE PLATES

TECHNICAL NOTES

NOTES TO THE PLATES

Frontispiece: Apartment windows on Central Park West bounce sunlight off the Central Receiving Reservoir.

1. The Manhattan Bridge, in the foreground, is the most heavily trafficked East River Bridge. The familiar form of the older Brooklyn Bridge, completed in 1883, stands behind it.

2. The George Washington Bridge is the third largest suspension bridge in the world supporting two levels of traffic. The lower level was added in 1964 to cope with the growing number of cars. Approximately 200,000 cars use the bridge daily and pay a 75¢ toll. These early-rising commuters find the going easy at 5:30 A.M.

3. The sun starts its climb over Midtown on a spring morning. The freighter is tied up near Canal Street on the lower West Side.

4. Houston and Delancy streets form parallel boundaries to the Baruch Houses on the Lower East Side.

5. "Big Allis," Con Edison's turbine power generator, faces Roosevelt Island. A model pedestrian city was designed for the island, but financial problems resulted in a scaled-down version. For access, there is a bridge from Queens and an aerial tramway from Manhattan.

6. This colorful footbridge connects Manhattan with Wards Island. In the early morning, waters of the East River are motionless.

7. The Queensboro Bridge, completed in 1909, has provided a backdrop for many movies of the 1940s and, more recently, Woody Allen's *Manhattan*.

8. The Brooklyn Bridge, a suspension bridge, hangs weightless over the East River.

9. A seaplane finds its wings near Wall Street on the East River and mysteriously ends its wake. Tricky wind patterns formed by buildings in the financial district and the wakes of numerous boats make this an adventurous form of urban transportation.

10. This container ship is being guided to a berth in New Jersey. A combination of New York City's crowded piers, reluctance of the unions to accept container shipping, and soaring land values, better suited to multistoried offices than warehouses, has caused cargo shipping to go elsewhere.

11. The *Eugenia*, a 3300-horsepower diesel tug, has a life-expectancy of 20 years on these waters. She has a crew of six that stays aboard for a week at a time.

12. Ellis Island, cold and empty now, in one year alone processed 1.3 million hopeful immigrants.

13. The Statue of Liberty beckons to all ship traffic through the Verrazano Narrows.

14. Run out of business by bridges and tunnels, these are the last remaining ferry terminals. In the past few years passenger fares have increased a whopping 500 per cent, so that today a ride to Staten Island costs 25¢.

15. Governors Island, a military installation run by the Coast Guard, lies off the tip of Lower Manhattan. Formerly known as Castle Williams, it was intended to crisscross the bay with cannonball fire with Castle Clinton in Battery Park during the War of 1812 — however "nary a shot was fired."

16. Dwarfed by a World Trade Tower, the Woolworth Building can bask in nostalgic glory; it held the "tallest building" record from 1913 to 1931. The Sears Tower in Chicago, completed in 1974, dashed the hopes of New Yorkers for the Trade Towers.

17. To protect themselves from Indians, Dutch colonists put up a wooden wall for protection. They named this place "Wall Street."

18. The density of skyscrapers and people in Wall Street is so high that neither sunlight nor traffic has much of a chance.

19. The business end of a skyscraper in Wall Street includes mechanical air-conditioning equipment and a water tank. New Yorkers consume 1.5 billion gallons of water a day.

20. Growing like trees in a forest, buildings sprout from the financial center in Lower Manhattan.

21. The South Street Seaport Museum, seen in the lower right, was started to maintain the original area that once housed the fish market, warehouses, and small businesses. Since 1966, the pier has been restored to its former splendor, along with nineteenth century ships that are berthed here.

22. A Bell Jet Ranger takes off from the East Thirty-fourth Street Skyport, one of five such helipads on the Island.

23. Heading up the East River toward Midtown.

24. The paths and lawns of Washington Square cover what was once a potter's field, a poor man's cemetery. The white marble arch commemorates the centennial of the first president.

25. Once the scene of large, unruly political gatherings, Union Square is today a favorite hangout for the sale of drugs. In the upper left-hand corner is Klein's, one of the original cut-rate stores.

26. Solar collectors, a wind generator, and a garden patch make their statement and provide alternative energy in a neighborhood on the Lower East Side.

27. Franklin D. Roosevelt Drive runs along the East River on the Lower East Side.

28. A manmade mountain of apartments and skyscrapers from the Lower East Side to Midtown. Midtown and the financial center developed to their high-rise form because the bedrock is closer to the surface.

29. Metropolitan Life Insurance Company built Stuyvesant Town after World War II for returning servicemen.

30. John D. Rockefeller donated the money to buy the land for the United Nations Headquarters, shown here with its view of the East River. This international body of peace devotes approximately 80 per cent of its budget to social and economic matters.

31–32. The abstract forms of the Exxon and McGraw-Hill buildings play off against each other near Forty-seventh Street. Their honeycombed floors stacked high upon each other merge into faceless structures.

33. The low round figure of Madison Square Garden stands out in contrast to the tall look of Midtown. The photograph was taken from the west side. Although nearly a fifth of America's top 500 companies have their headquarters in New York City, the average size of a city business is 15 workers. The familiar shape of the Empire State Building overlooks the scene.

34. The Citicorp Center, midtown's most exciting and recent addition, is an aluminum-skinned beauty that reflects the mood of the day and features a street-level, sky-lit atrium that includes restaurants, shops, public gathering places, and even a church.

35. The Chrysler Building, a long-time favorite of many New Yorkers, is undergoing a multimillion-dollar interior refurbishing. The huge radiator-cap gargoyles reflect the products of its first owner.

36. Once a residential area, Park Avenue succumbed to the building boom during the fifties and sixties. Here at Park Avenue and Fifty-third Street, the Lever House casts a broken reflection over the street below.

37. Situated behind the New York Public Library, Bryant Park attracts a crowd of lunchtime office workers.

38. Dedicated to the patron saint of the Irish, St. Patrick's Cathedral reminds Fifth Avenue that "small is beautiful." Flying in close quarters like this was probably the most dangerous part of this project. Wind currents buffet the aircraft, and generally speaking, there is no place to make an auto-rotation (glide) should the engine quit.

39. The New Yorker, home of the weekly cosmopolitan magazine, is well identified. Their offices are on West Forty-third.

40. A Neo-Gothic building lurks in the caverns of the West Forties.

41. As if to release the pressure from within, New York steams against the Midtown skyline on a summer day.

42–43. The PANAM and RCA buildings beam their logos for a nighttime reminder. These nighttime shots were taken with Kodachrome's new 400

ASA slide film which opens up totally new possibilities in available light photography.

44. The gently draped lights of the Brooklyn Bridge appear at the top of this Lower Manhattan view.

45. Central Park, New York City's oasis, stretches from 59th to 110th streets, encompassing 840 acres. Imagine this photograph with solid buildings in place of the park.

46. This view is from the Conservatory Gardens, looking south to Midtown.

47. East Side apartment dwellers enjoy this vista of their park. Central Park was named a National Historic Landmark in 1965, which presumably protects it from being sold by the city fathers to bail out the financially depressed city.

48. Cars and taxis wind their way through the park on a spring drive. These original carriage drives were curved to prevent racing.

49. Springtime in the Conservatory Gardens.

50. A young man finds a quite nook near The Lake.

51. The Central Receiving Reservoir, Eighty-ninth and Ninetieth streets on the West Side, the Hudson River, and the New Jersey shore stretch out from bottom to top.

52. Joggers run the perimeter of the reservoir, with cherry blossoms in full bloom sweetening their way.

53. People and trees cluster near the Band Shell.

54. Friends and lovers have been pulling oars since 1860, when boats were first introduced on The Lake.

55. Rowboats and canoes can be rented at Loeb Boat House.

56. Bethesda Fountain, bronze Angel of the Waters, plays host, but without the waters.

57. Midway through Central Park are the playing fields of The Great Lawn. City league and interoffice softball games are regular events at this active spot.

58–61. A variety of summer sports take place in little pockets of activity all over the park.

62. A long view of the tennis courts shows the Upper West Side in the background.

63. The Metropolitan Museum of Art's new climate-controlled addition houses, among numerous other works of art, an Egyptian temple. So vast is the collection of the Met that only a portion of their holdings is on display at any given time.

64. The benefactor, Solomon Guggenheim, and the designer, Frank Lloyd Wright, are as well known as the modern artists whose works hang in their museum. The Guggenheim Museum is on Fifth Avenue, five blocks up from the Met.

65. With shadows spilling over, Midtown buildings come to a screeching halt at Central Park South.

66. A peaceful moment on a secluded path in Central Park. There is nothing to suggest here that these hikers aren't in the hills of Vermont.

67. Carriage riders enjoy the middle lane of East Drive on a crisp fall day. Long before Cadillacs and Mercedes vied for attention, the carriage was the symbol of wealth.

68. As they might in any other place, kids enjoy a winter's day on Conservatory Pond.

69. Cross-country skiers traverse The Great Lawn the day after a snowfall.

70. A chilly view up the length of Central Park from over Midtown. Wollman Memorial Rink, a favorite for ice-skaters, is located in the foreground.

71. Sun spotlights a sunbather on a green oasis in a sea of nondescript rooftops.

72. A woman jogging on her rooftop in the fashionable East Side.

73. Who says New Yorkers can't have their cake and eat it too? Roof gardens on Lexington Avenue near Twenty-eighth.

74. Cars and taxis crowd the entrance to the Queens–Midtown Tunnel at East Thirty-sixth Street for the evening commute.

75. Gracie Mansion, the Mayor's official residence, is set back in Carl Schurz Park on the East River.

76. A look down the East River from over Wards Island.

77. The Harlem River flows into the East River near the Triborough Bridge. The George Washington Bridge is visible in the upper left.

78. In a direct line from Midtown, the newly renovated Yankee Stadium is prepared for a night game.

79. High Bridge, completed in 1848, is the oldest connection to Manhattan. Originally called Aqueduct Bridge, it still brings water into the City. Passing under the bridge is less potable water.

80. Commuters heading home on the Cross Bronx Expressway.

81. These big switching yards in Upper Manhattan provide rail service to the Island. The last numbered street at the upper tip is 220th.

82. Like a green river, Morningside Park branches into Central Park.

83. Perched on Morningside Heights next to the Hudson River, Columbia University enjoys a choice piece of geography on Manhattan. Columbia purchased this property from Bloomingdale Insane Asylum. The imposing Cathedral of St. John The Divine sits to the left.

84. The cemetery at the Cathedral of St. John The Divine.

85. Columbia helps finance this vast educational establishment with the rent collected from the land beneath Rockefeller Center. In the center of this picture is Low Memorial Library and, on a nearby street in the upper left, Barnard College.

86. On the steps of Low Memorial Library, the Statue of Alma Mater presides over a noontime rock concert.

87. Against the colorless backdrop of rooftops in Harlem, the morning wash dries.

88. A rooftop playground contrasts strangely with the yard below.

89. Row houses in Harlem near St. Nicholas Avenue.

90. Known for its modern interpretation of theology, Union Theological Seminary presents a symmetrical shape. The seminary is located on West 120th Street.

91. Riverside Drive at 100th Street with Riverside Park under a fresh mantle of snow.

92. The Soldiers' and Sailors' Monument at Riverside Drive and West Eighty-ninth is dedicated to the Civil War dead.

93. Row houses in the West Seventies. These houses, with their assortment of colors, designs, and front peaks, reflect the influence of early Dutch colonists.

94. A dilapidated pier on the West Side sags into the Hudson River.

95. This photograph of the West Side piers and Midtown indicates where the money is — office buildings, not shipping.

96. A tug arranges four barges loaded with gravel. To withstand the pushing and bumping, tugs' hulls are overbuilt.

97. Another tug guides four, seemingly unmanageable barges across the Upper Bay.

98. Appropriately named, The Circle Line circles Manhattan for an interesting perspective of the Island.

99. Residents in the Beresford Apartments on the West Side enjoy a most spectacular view of Central Park.

100. Steel reinforcing bars are laid down for another floor on a West Side apartment.

101. This early evening view taken from over West Fifty-seventh Street includes Lincoln Center, the white cluster of buildings in the center.

102. A crowded view of apartment houses on the Upper East Side.

103. Sunset approaches with this view of Upper Manhattan photographed from over the Hudson. The City takes a short rest before it gears up for the night life.

104. Riverside Church yellows from the setting sun. The turquoise-colored rooftops of Columbia University are next to it.

105. Thousands have left the World Trade Towers for home as this tugboat chugs, undaunted, to another job. Tugboats are dispatched from offices high in the financial district where the operator can see all the waterways around the Island.

106. Two empty passenger cruise ships lie tied up on the West Side. The smaller one on the right bears the Russian hammer and sickle.

107. A late evening sail off the lower tip of Manhattan puts everything back in perspective.

108. A look from within the financial district.

109. The Staten Island Ferry heads home.

110. The East River and Midtown.

TECHNICAL NOTES

These photographs were taken at different seasons of the year during two-day shooting sessions. I went up about six times for a total of 24 hours' flying time. The shooting ratio of number of frames taken to final selections was 40:1.

The weather is, of course, the prime factor in determining when shooting sessions are permissible. A cold front that brings cool northwest breezes from Canada usually signals the beginning of a three-day clearing pattern that will leave the City free of suspended smog and soot.

Preparation for the day's flight starts with the removal of the helicopter door, to prevent reflections and distortions. If I am flying with a new pilot, a simple set of hand signals is rehearsed before the engine is started. We could shout at each other, but that quickly becomes tiresome. I also reject the use of a headset because I want to minimize my involvement with the pilot's concerns of running the aircraft.

We flew out of Teterboro Airport in nearby New Jersey and used Pan Am's Metroport helipad at East Sixtieth Street for an occasional pit-stop. During commuter hours this riverside airstrip looks like the beachhead at Normandy as scores of helicopters swarm in and out with their cargo of top-level executives.

Obtaining clearance over Manhattan was never a problem. The air space over the Island is controlled by La Guardia Airport and we were never denied access. Our maximum ceiling was usually 1000 feet; over the water and Central Park we were as low as 300 feet.

My equipment included two motorized Nikon F2A's, a 105mm lens, a 35mm, a 28mm, and 24mm. All the lenses were equipped with polarizing filters. F-stop openings were controlled by an EE servo motor, and shutter speeds were at 1/500 for the 105mm lens and 1/250 for the wide-angles. Kodachrome 64 and Ektachrome 400 films with slightly overrated ASA's were used.